Earl Cunningham

DREAMS REALIZED

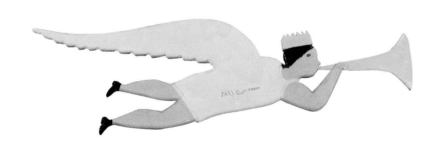

THE MENNELLO MUSEUM OF AMERICAN FOLK ART
ORLANDO, FLORIDA

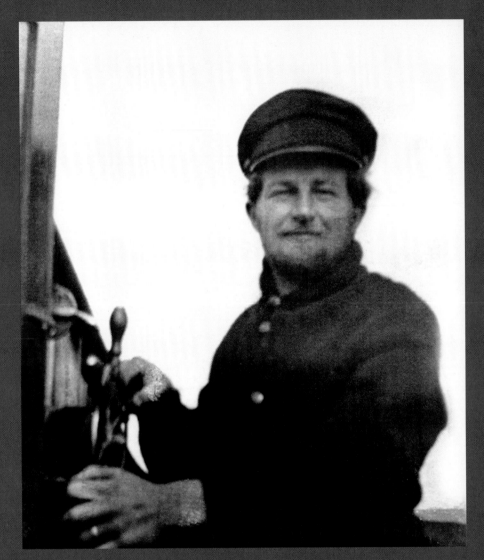

Captain Earl Cunningham on Hokona, 1916

Earl Cunningham | DREAMS REALIZED

with an essay by H. Barbara Weinberg

Introduction by Mayor Glenda E. Hood
Foreword by Frank Holt
Preface by Michael A. Mennello
The Collector's Story by Marilyn L. Mennello

Dedicated to Glenda E. Hood, Mayor of Orlando

THE MENNELLO MUSEUM OF AMERICAN FOLK ART
ORLANDO, FLORIDA

Sponsor's Statement

NationsBank

On behalf of the entire NationsBank team in Central Florida, I wish you an enjoyable tour of this rich collection of American Folk Art. It is a pleasure to bring you this catalog and to welcome you to The Mennello Museum of American Folk Art.

As you discover the personalities in these vibrant pieces, I hope you find — as I have — that diversity of styles, vision and perspective is as healthy for us in art as in business. We are fortunate to enjoy both a region and an art community that celebrates differing ideas, opinions and perspectives.

John S. Lord
NationsBank
Central Florida Market President

Contents

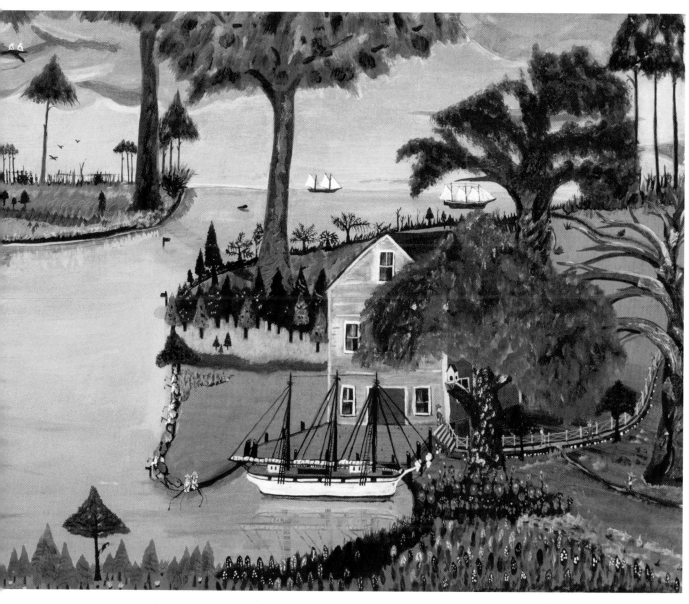

Nassau Sound, *ca. 1945 (cat. 22)*

Acknowledgments

The opening of this museum has been made possible through the support and involvement of many talented and dedicated individuals. Mayor Glenda E. Hood provided the vision, the City Council gave their full support and Marilyn L. and Michael A. Mennello have given generously from their collection, their time and expertise.

The Mayor's City staff has given many hours in providing support for all phases of the project, including the renovation of the museum facility. As a result of much hard work, the building has become an aesthetically pleasing and appropriate setting for the display of the collection. The technical, monitoring and safety systems are among the finest available.

Funds provided by Orange County Chairman Linda C. Chapin and the Orange County Commission have made possible the creation of the outdoor sculpture garden. A newly renovated landscape will provide the background for the works displayed there.

Our sincere gratitude to H. Barbara Weinberg, 20th Century American Art, Metropolitan Museum of Art for her insightful essay on Earl Cunningham; Lowery Stokes Sims, Curator, 20th Century Art, Metropolitan Museum of Art; Carolyn Weekley, Director, Ann Motley, Registrar, Abby Aldrich Rockefeller Folk Art Center, Williamsburg; Dr. Elizabeth Broun, Director, Abigail Terrones, Associate Registrar, National Museum of American Art, Washington, D.C.; Ned Rifkin, Director, Jody Cohen,, Associate Registrar, High Museum of Art, Atlanta; Gerard Wertkin, Director, Anne Marie Riley, Registrar, Janie Fire, Associate Registrar, Museum of American Folk Art, New York City; Marena Grant-Morrisey, Director, Andrea Long, Registrar, Orlando Museum of Art, Frank Rigg, Curator, Jim Wagner, Curatorial Assistant, John F. Kennedy Library, Boston; Gary R. Libby, Director, David Swoyer, Senior Curator, Museum of Arts and Sciences, Daytona Beach; Robert Harper, Director, Irene L. Laurie, Registrar, Lightner Museum, St. Augustine for arranging for the loan of Earl Cunningham paintings from their collections.

Special recognition is given to Mrs. Justin Dart for the wonderful gift of a major Cunningham painting and to Tom Yochum of SunTrust.

Thanks also needs to be extended to Dr. Maude Southwell Wahlman, University of Missouri-Kansas City and Debra J. Force, Director, Beacon Hill Fine Art, New York for their assistance in the appraisal of the collection. Additionally, the many contributions of Bonnie Jones, Pruet Conservation; Lisa Nason; Secretary of State Sandy Mortham; Bob Melanson; Lois Cooksey and Ronald Stow should be noted.

We also wish to express our appreciation to John Lord, NationsBank for his generous donation.

F.H.

Introduction

Dear Friends:

Discovering. Preserving. Interpreting. Earl Cunningham did all of this when he put a brush to canvas. You are doing the same here in Orlando's newest cultural venue: The Mennello Museum of American Folk Art.

The Museum's outstanding permanent collection of Earl Cunningham paintings and other works serve Orlando's constantly growing cultural audience. This museum is a treasure for art lovers and brings the vision of traditional and contemporary folk artists to Orlando.

Orlando is one of a few cities that boast such a rich museum dedicated to 20th century American folk art.

Orlando is a city of diverse cultural offerings. The Mennello Museum of American Folk Art provides our City with a unique opportunity to exhibit works that showcase our cultural diversity.

Earl Cunningham's works are endlessly inventive and boldly colorful. He painted seascapes and landscapes that combined elements from different times and places into brilliantly colored, idyllic fantasies. His vision imagery and style add a dazzling facet to the kaleidoscope of American folk art.

The City of Orlando is proud to be home to Earl Cunningham's collection, and is thankful to private collectors Michael and Marilyn Mennello for their donation of perhaps the best collection of Cunningham's work in the world. Their desire gave birth to this museum, and art enthusiasts from across the United States owe the Mennellos a great deal of gratitude.

The Mennello Museum of American Folk Art is an integral part of the emerging Orlando cultural scene. Earl Cunningham believed all his works were members of his family. At the Mennello Museum of American Folk Art we want you to feel like family as well and enjoy the great works on display.

Glenda E. Hood

Glenda E. Hood
Mayor

Mayor Glenda E. Hood, shown with the Cunningham painting that graces her office.

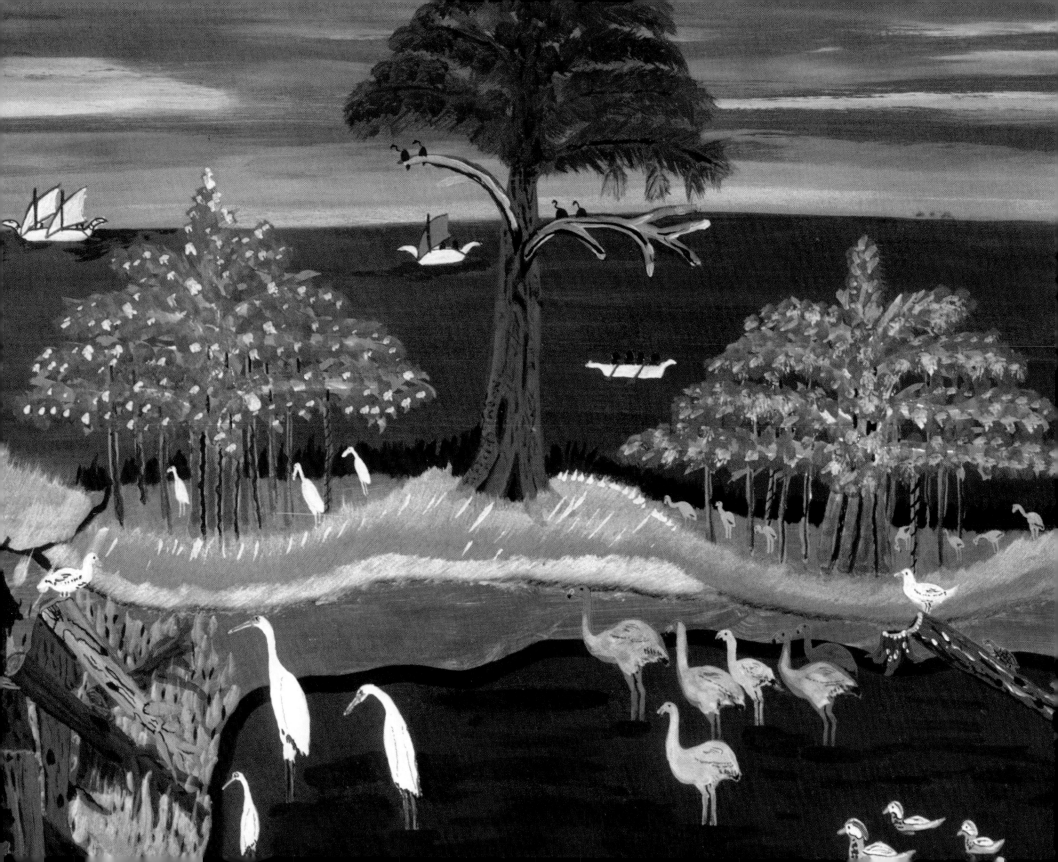

Lenders to the Exhibition

Abby Aldrich Rockefeller Folk Art Center
Williamsburg, Virginia

High Museum of Art
Atlanta, Georgia

John F. Kennedy Library and Museum
Boston, Massachusetts

Lightner Museum
St. Augustine, Florida

Marilyn and Michael Mennello
Winter Park, Florida

Museum of American Folk Art
New York City

National Museum of American Art
Smithsonian Institution, Washington, D.C.

Orlando Museum of Art
Orlando, Florida

The Metropolitan Museum of Art
New York City, New York

The Museum of Arts and Sciences
Daytona Beach, Florida

Left, detail from Banyon Tree Camp *(cat. 34)*

Foreword

There seems to be two types of dreams — those we dream at night when we sleep and those we dream during the day when we imagine what is possible in our lives.

We do not have an indication of what Earl Cunningham dreamed of during the night, but we do know that during the day, he dreamed of a museum bringing all of his works of art together into one place. His art is both romantic and delightful and one can only imagine that at times they represent his dreams.

Marilyn and Michael Mennello shared Earl Cunningham's dream of a museum. This exhibit and The Mennello Museum of American Folk Art would not be possible without their collective will.

"Dreams Realized," the title of this catalog and exhibit, is appropriate in many ways. It is the manifestation of Earl Cunningham's dream. It is the culmination of the Mennello's dream. And it is, to a large extent, the realization of a dream that many, including the City, did not even know they had. Eventually, the Museum will exhibit works of art by many other "visionary" dreamers and will become a major force in the cultural life of Central Florida.

This exhibit and the Museum in which it is displayed is the result of the efforts of many people. It is also one of my own personal dreams, the accomplishment of which I never imagined would come true.

Preface

MICHAEL A. MENNELLO

Holger Cahill, the pioneering art historian, museum director and curator, viewed folk art as "the unconventional side of the American tradition in the fine arts." Not all scholars agree. Jean Lipman viewed folk art as "artistic efforts confined within time boundaries."

Folk art was a prime product of the new American democracy, which strongly represented the spirit of this country. American folk art is the art of the people – often forgotten men and women. But American folk art is not an unskilled imitation of fine art. It is produced by amateurs who work for their own gratification and the applause of their families and neighbors, and by artisans and craftsmen of varying degrees of skills and artistic sensitivity who work for pay.

Earl Cunningham painted for his own gratification for 27 years in the back room of his little shop on St. George Street in St. Augustine, Florida. He seldom sold a painting and frequently dreamed of one day having all of his paintings together in a museum.

He would be so pleased to know that thanks to Orlando's Mayor, Glenda E. Hood and the Orlando City Council, his paintings will have a permanent home in the new Mennello Museum of American Folk Art in Loch Haven Park.

My wife, Marilyn and I have, for the past 12 years, nurtured and secured for the world the works of Earl Cunningham and we are grateful to the City of Orlando for creating this wonderful museum which will house the magnificent Cunningham collection.

In organizing this catalog and the premier exhibition we have been greatly assisted by Frank Holt, the new Museum's director and want to thank him for his dedication in overseeing the overwhelming and demanding task of remodeling the building.

We are equally indebted to all of the institutions which have graciously shared their paintings for this exhibition.

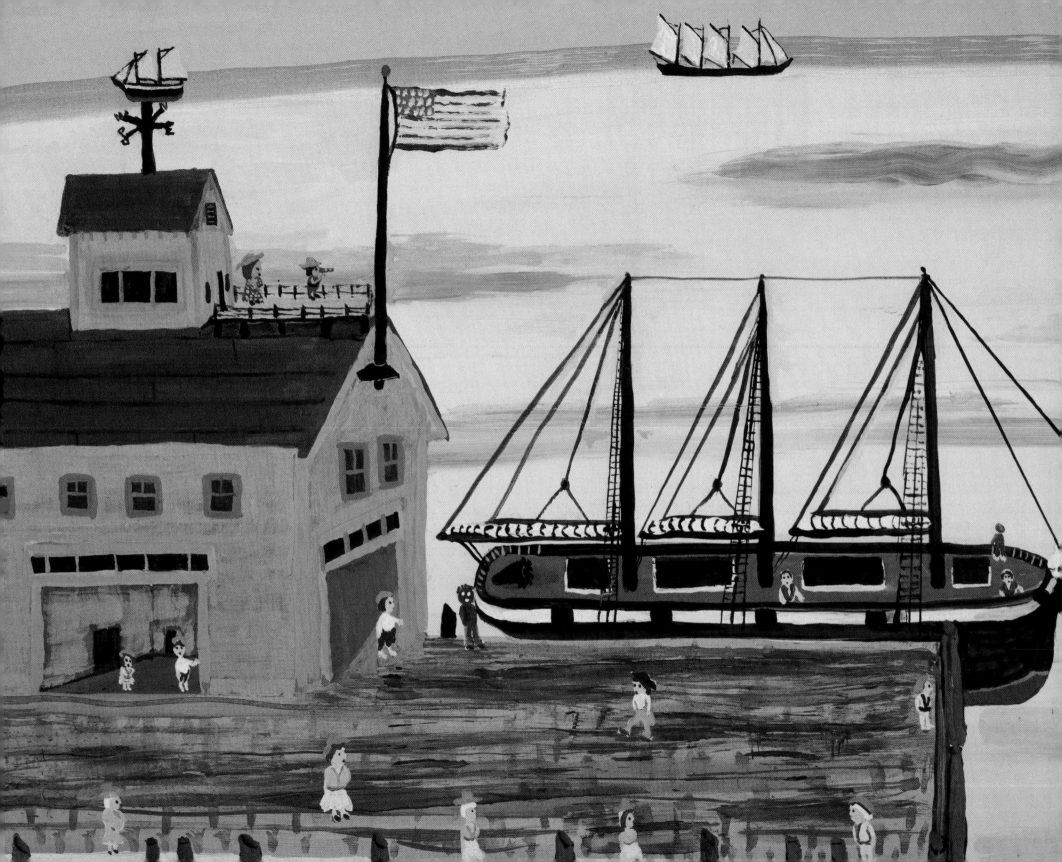

The Collector's Story

MARILYN LOGSDON MENNELLO

Earl Cunningham (1893–1977)

The Collectors: Michael and Marilyn Mennello of Winter Park, Florida. This is their story of how they collected the majority of the life's work of one of America's major 20th Century folk artists, Earl Cunningham, and in doing so how it changed their lives, as told by Marilyn Mennello.

W here does one begin to tell a story that has changed one's life? From the beginning, you would say, so that is where I shall start, from the beginning.

There is a word called "Fate." The dictionary describes it as "that which is destined or decreed." I had never thought too seriously about "Fate" back in 1969, but I certainly do now because I know it was "Fate" that took me to St. Augustine, Florida that bright, sunny day so many years ago. It was in November 1969 to be exact. A friend of mine, Jane Dart (Mrs. Justin Dart), from Los Angeles, was visiting me. She suggested that I take her to see St. Augustine since she had never been there. I happily agreed and we left Winter Park, Florida early in the morning as it was a two and one half hour drive.

We arrived in St. Augustine about 10:30 a.m. and started walking down the main street (St. George Street) in the old city. This was long before the city's restoration had begun. We browsed in the little shops and soon opened the door to the "Over-Fork Gallery." We went in to see if we could find some hidden treasure. The shop was lined with glass cases filled with objects which we immediately determined were of little interest to us, but I was struck by the neatness of the cases. All of the old curios were placed in separate rows with everything of like kind placed together for easier viewing. A small, white-haired, bespectacled man stood quietly in the corner observing us and another couple present in the shop. Jane and I knew we had seen enough and were eager to get on with our sight-seeing. We left the shop and started walking down the sidewalk toward the city. As we started walking, we glanced into a grimy window that was part of an extension to the

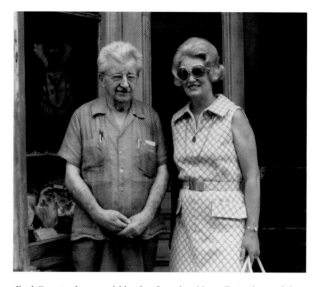

Earl Cunningham and Marilyn Logsdon Mennello in front of the Over-Fork Gallery, 1970. Photo by Lynda Wilson

Left, detail from View from the Widow's Walk, *ca. 1955 (cat. 32)*

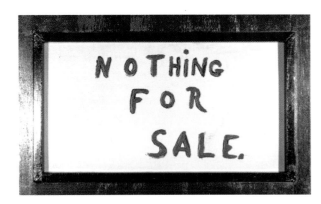

Hand-painted sign posted in the storefront window at Earl Cunningham's Over-Fork Gallery

shop and noticed some wonderful primitive paintings on small easels. We just stopped and stared. Both of us were mad about primitive art and we were terribly excited about seeing these splendid paintings. We noticed each painting was signed by an "Earl Cunningham." Then we saw a sign that read "These paintings are not for sale." Jane and I looked at each other in dismay and turned right around to go back into the shop. I approached the elderly gentleman still standing in the corner.

"Are you Mr. Cunningham?"

"I am."

"Sir, why aren't the paintings for sale? We just love them."

"Just because they're not." His answers were abrupt.

"Do you have others?"

"I do." He paused thinking and then said: "You wait right here."

He told the young couple that was still in the store that he was sure they didn't want anything and asked them to leave. He closed the door and locked it and said with a distinctive Maine accent "you come with me."

We were led through a small, dark kitchen to a large workroom. We were stunned. As chills went through us, our faces lit up with the delight of children in a candy store. There, amidst the harsh reality of a man selling rather worthless curios to earn a meager living, were hundreds of the most captivating, primitive paintings we had ever seen. The room was a gallery with his waterscapes hung floor to ceiling, and painted in brilliant colors of yellows, blues, and greens. There were paintings of three masted schooners larger than the mountains, and lighthouses striped like barber poles from which he had painted rays of light beaming out hope to the little people in the ships below. He painted with a child-like freshness that simply fascinated us and made us want to possess every painting there.

Our exclamations seemed to bring Mr. Cunningham to life and he spent the next twenty minutes telling us stories about his life. He had left his home in Edgecomb, Maine as a very young boy of thirteen. He bought some dime store paints and painted on boards from boxes that had

washed in from the sea, and sold his pictures to buy food. He also sold trinkets such as pocket knives, old beads, needles and thimbles — anything he could trade or sell — from a suitcase strapped on his back. In 1912, at the age of nineteen, he graduated from the Hamlin-Foster Company Academy of Automobile Engineers in Portland, Maine. Later, he became a seaman and sailed the east coast of the United States storing memories of ships, people and colorful sunsets. But even during those years, he always found time to paint. He told us he had done some pictures for the Michigan Historical Society, and that he had lived and painted in Georgia and North and South Carolina.

In 1949, Mr. Cunningham took up permanent residency in St. Augustine, Florida. He told us that he had gone into the Everglades to see the Seminole Indian camps where he got ideas for the Seminole paintings which were hanging on the gallery walls. I remember his saying to us: "You may think water looks blue, but not in those Everglades it's not — it's brown — just as brown as it can be." And sure enough, all of his Everglades pictures had authentic looking chickees (Seminole houses), authentic dugout canoes and brown water.

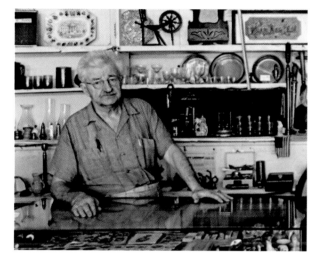

Earl Cunningham behind the counter at the Over-Fork Gallery, 1970. Photograph by Jerry Uelsmann

His paintings of Eastern Indians were very different. Those Indians were housed in teepees and floated in birch bark canoes on rivers and lakes of bright pink, orange, yellow, and sometimes blue water. Then there were the typical Maine and east coast paintings with black schooners and salt box shaped houses with people fishing and crowded marinas. Some of his paintings were pure fantasy with combinations of schooners, saltbox houses, cracker cabins, and an ever recurring Viking ship. Each painting was always a seascape or waterscape with the water painted in vibrant, rich beautiful colors. Earl Cunningham's love of America was also very apparent because he painted the American flag in many of his paintings.

Jane and I could not believe that Mr. Cunningham would not sell us a painting. He said: "You see, someone is going to come 'round here and buy all my paintings at one time for $40,000. You know, Jackie Kennedy has one of my paintings. If you had watched President Kennedy on television, you could have seen my painting right back of the President's head in his office." This statement has now been documented by a receipt of delivery of a Cunningham painting to the

THE WHITE HOUSE
WASHINGTON

May 9, 1961

Dear Mr. Cunningham:

On behalf of Mrs. Kennedy, I
would like to thank you for your thoughtfulness
in sending her your original painting "The Ever-
glades."¹² Since she is eager to encourage an
interest in, and a development of, the Arts in
this country, you can imagine her appreciation
of your work.

With sincere thanks and very
best wishes to you for your continued success,

Sincerely,

Letitia Baldrige

Letitia Baldrige
Social Secretary

Mr. Earl Cunningham
49 St. George Street
St. Augustine, Florida

*Letter of thanks from Mrs. John F. Kennedy's Personal Secretary
dated May 9, 1961*

White House on January 26, 1961 and a letter of thanks from Mrs. Kennedy's personal secretary, Letitia Baldridge, dated May 9, 1961. Both documents are currently in our files.

Needless to say, we were impressed. After much discussion, we finally convinced Mr. Cunningham to sell us each a painting. He told us we could choose any painting we wished. That was a difficult task for me — in fact nearly impossible — because I liked them all. My heart was racing because this was a chance of a lifetime. Finally, Jane made her choice and I made mine — yes, I was sure, that was the one I wanted! It had violet colored water, a white house with stairs to the Widow's Walk, and little people with binoculars looking at the ships at sea. On the opposite side of this New England scene was a smaller house with bright pink flamingos standing in the water. I adore that painting as much today as I did then. My painting was unframed and Mr. Cunningham said he would frame it in one of his handmade frames like he used on all of his paintings. His handmade frames were a work of art in themselves, and added a great deal of character to each of his pictures.

Now that we had made our selections, we asked the price. He dropped his eyes a little and said: "They will cost you $500 each." He paused and added: "Cash."

"But Mr. Cunningham," we protested "we don't have $1,000 cash with us!"

I could tell that he was not going to back down on his terms, and that he would sell only for cash. I told him I would return with the money the following week, and after a few more minutes of conversation, we left the "Over-Fork Gallery" and continued on our way down St. George Street. Little did I realize that "Fate" was walking hand-in-hand with me that day.

The next day, I excitedly called the Loch Haven Art Center (now the Orlando Museum of Art) to speak with the director of the center, David Reese. I told David about the Earl Cunningham paintings I had seen and that they would make a great exhibition for the Art Center, if he could persuade Mr. Cunningham to exhibit his paintings. David agreed to drive back to St. Augustine with me the next week. I had $1,000 cash with me for the paintings.

I think Mr. Cunningham was stunned to see me walk into his shop, but as he had promised, my painting had a handsome new frame. After some discussion, Mr. Cunningham began to show

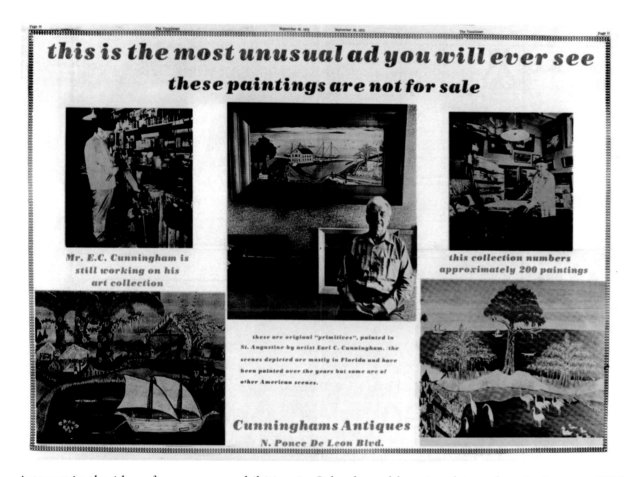

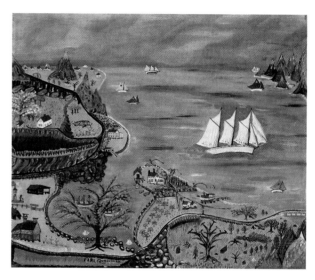

Cunningham's *two-page ad in* The Vacationer, *September 26, 1973*

Untitled, 1928. Gift of Mrs. Justin Dart to The Mennello Museum of American Folk Art (cat. 4)

interest in the idea of a one-man exhibition in Orlando and he agreed to a show in January 1970 at the Loch Haven Art Center. It was a splendid exhibition, and the museum purchased two of his paintings for their permanent collection. Earl Cunningham was seventy-seven years old, and "Fate" had chosen me to organize his first one-man show.

I returned to Winter Park with the Cunningham paintings and shipped Jane Dart's painting to her. Jane has enjoyed her Earl Cunningham painting all of these years but when she heard there was going to be a museum in Orlando featuring the Earl Cunningham paintings, she called me

Earl Cunningham, 1970. Photograph by Jerry Uelsmann

and very generously and graciously donated her beautiful painting to "The Mennello Museum of American Folk Art." It is so significant that Jane's Cunningham painting and mine will be hanging together again after all of these years for all the world to enjoy.

Two years later, the Museum of Arts and Sciences in Daytona Beach, Florida had a large exhibition of Cunningham's work and there was a great deal of publicity about the show. This must have pleased Mr. Cunningham. There was even a small catalog published which he obviously helped to write. There were some interviews in the local papers with photographs of Mr. Cunningham. He was being recognized by the art world and he was enjoying it. His dream of keeping all of his paintings together so the world could see them as a group, was coming true. It was about that time that Mr. Cunningham asked Jerry Uelsmann to take some photographs of his shop and gallery. Mr. Uelsmann agreed and traded his photographic work for a Cunningham painting. These photographs provide a tremendous documentation of Mr. Cunningham's studio and old St. Augustine because the building that housed his gallery and studio was torn down during the restoration of St. George Street.

During the next few years, I would see Mr. Cunningham when I visited St. Augustine, but he would never sell me another painting. I asked him once why he had sold me the painting I owned and he said: "Because I never thought you would come back." In 1975, Mr. Cunningham moved to a new location on US 1 in St. Augustine.

I lost touch with him at that point because I had married Michael Mennello and my life was filled with new adventures and a different kind of art. My husband collected Old Masters paintings, and he later became interested in post impressionist French and American art. But, "Fate" was ever present. I had married a true art collector and I must say here, that the Cunningham collection would never have been preserved without the dedication of Michael Mennello. It was his encouragement and help that kept me focused. Without this, I could have very easily given up my mission to acquire this great collection.

One day in 1984, Michael came home saying "Did you know your artist, Earl Cunningham, has been published? He's published in Jay Johnson's and William C. Ketchum, Jr.'s new book

"American Folk Art Of The Twentieth Century." I was delighted, of course.

The very next month, my daughter, Lynda Wilson, went to St. Augustine to visit, and Michael asked her to find Mr. Cunningham to purchase another painting for me. She called me from St. Augustine to tell me Mr. Cunningham had died in December 1977 by his own hand. From his diary, which I now own, he made a notation that said: "1977 — 450 paintings finished." There would be no more beautiful, fanciful paintings by the "Crusty Dragon of St. George Street" as he had become known.

My daughter left my name in several art galleries around St. Augustine in case anyone could find any Cunningham paintings for me. A few weeks later, I answered the telephone to hear a man's voice telling me he had sixty-two Cunningham paintings to sell and that he would sell no fewer than that number. After several weeks of negotiations, Michael decided to purchase the sixty-two paintings, and that was the beginning of the collection. We drove to St. Augustine to pick up the paintings, and I will never forget our feeling of joy when we saw them. We knew we had done the right thing. On the drive home we realized we were making a great commitment. We talked about the other paintings we knew existed. Mr. Cunningham died without a will and his paintings were dispersed to many of his relatives around the country.

Self-portrait, fabric doll

Michael and I agreed that we would try to find the remaining paintings and bring this great collection together again as Mr. Cunningham wanted. We worked through the estate lawyers and became detectives, finding paintings as far away as Seattle, Washington. I remember flying into Maine in the cold of December 1984 to negotiate the purchase of some of his paintings. They were stacked in an old house, without heat, and had been there for years. We found another group of paintings in Connecticut in an attic without air conditioning. If the majority of the paintings had not been on Masonite, they never would have survived for the world to enjoy today.

By the middle of 1985, we had collected the majority of the paintings we now own. Our lives became obsessed with Cunningham. We felt as if he were a member of our family. Whenever Michael and I saw a bright sunset we would say "There is a Cunningham sky." We even named our new cat Earl Cunningham (EC).

Palm Tree Study, *1970. Gouache on cardboard*

Each painting was cleaned and the frames revarnished by Bonnie Jones of Pruet Conservation in Geneva, Florida. Bonnie finally had to come to our home to do her work in our game room which we dedicated to the Cunninghams. Storing 350 paintings took a great deal of space. Each painting was photographed, measured, numbered and cataloged.

Finally we were ready to have the collection evaluated. We called Dr. Robert Bishop, Director of the Museum of American Folk Art in New York City. He came to Florida to see the works and to give us some guidance as to what to do next. He was familiar with Cunningham's work, but when he saw the paintings as a collection, he was truly overwhelmed. He suggested we take sixty-five of the prime paintings to the New York University Galleries for an exhibition on March 11, 1986. The show was presented by the Museum of American Folk Art, the Center for American Art, and the New York University. It was a great success.

Since that first New York exhibition in 1986, the paintings of Earl Cunningham have traveled across this country to over 30 museums. The Art In Embassies program in Washington, D.C. has

Front and back sides of a chicken feeder, ca. 1920. Made and painted by Earl Cunningham in memory of his days as a chicken farmer

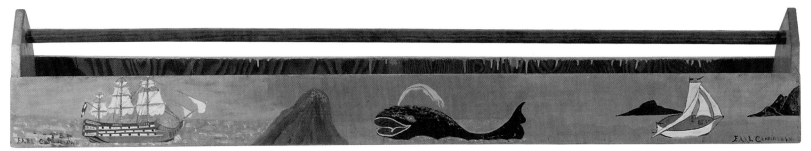

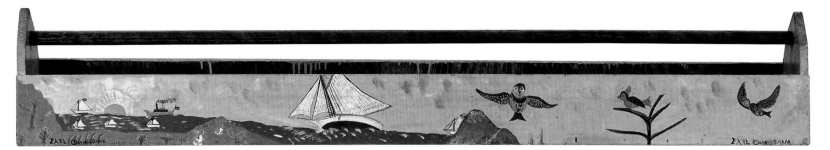

sent Cunningham paintings to embassies in Luxembourg, Geneva, Switzerland and Caracas, Venezuela. His work is now represented in 10 museums in the United States. The most recent museum to include his work in their permanent collection is The Metropolitan Museum of Art in New York.

Art critics have called Cunningham "A Primitive Genius", "Grandpa Moses", and "A True Primitive Fauve." In February 1995, "New York Times" art critic, Roberta Smith, gave a glowing review of Cunningham's work and compared him to Joseph Albers and H.C. Westerman.

In 1994, Harry N. Abrams, Inc. published a wonderful monograph on Cunningham. The book was written by art historian, Robert Hobbs and titled "Earl Cunningham: Painting An American Eden." Earl Cunningham was now becoming a household name.

After reading this story, I am sure you will agree with me that it truly was "Fate" that took me to St. Augustine so many years ago. If anyone had told me in 1969 when I first met Earl Cunningham that I would one day be the curator of his great collection of paintings, I would have laughed and called them quite mad. It has meant years of hard work and commitment caring for the Cunningham paintings. But it has also been years of joy and satisfaction. Without my husband Michael's and my efforts it would have been years before Earl Cunningham would have achieved his rightful place in the history of America's artistic heritage.

Now, once again, "Fate" has stepped into Cunningham's world and his dreams and ours have become a reality. "The Mennello Museum of American Folk Art" has been established in Orlando's beautiful Loch Haven Park because of the foresight of Mayor Glenda Hood and the City Council's understanding of the importance of preserving our cultural heritage. The basis of the Museum's collection will be the work of Earl Cunningham, but we are pleased that the Museum will represent all aspects of American folk art. It will become a major force in the State of Florida and in the United States in educating the public about America's folk artists.

Is it any wonder that the title of this catalog is "Earl Cunningham, Dreams Realized"? 🦅

Archangel Gabriel. *Watercolor*

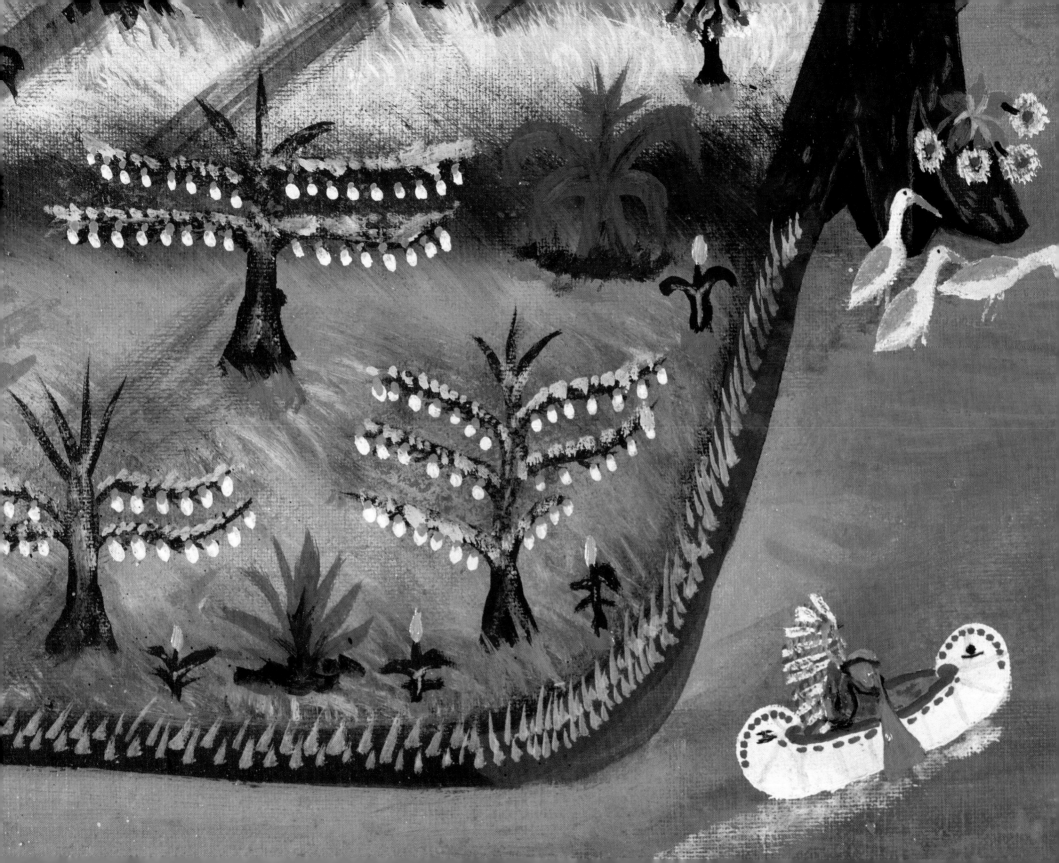

From Sea to Shining Sea:
The American Dream World of Earl Cunningham

H. BARBARA WEINBERG

Life is simple and fun if you let it be. — Earl Cunningham, 1969

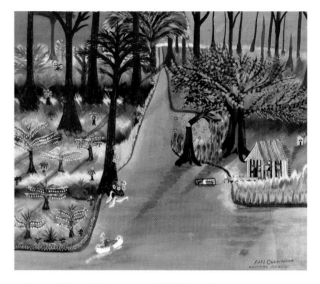

Ashepoo River in Spring, *ca. 1930 (cat. 7)*

Scenes by the self-taught American marine painter Earl Cunningham (1893–1977) are visions transcribed from his mind's eye. In *View from the Widow's Walk* (ca. 1955),[1] for example, the boathouse surmounted by a widow's walk (at the left) defines a New England locale. Tiny figures fish and sail a boat from the small dock, stroll on the broad boardwalk, gaze through binoculars from the widow's walk, and peer over the rails of a three-masted ship moored alongside the boardwalk and fastened to a buoy surmounted by a huge pelican. The pelican, the American flag snapping from the gable of the boathouse, and the three-masted ships under full sail direct our view to the right, across a cotton-candy-pink sea, to a different clime. Here, a palm tree punctuates the coastal promontory, flamingos fill the beach, a tiny sailboat is secured to a tiny dock, and a verdant lawn sets off flowering shrubs, huge blossoms, and a tile-roofed golden stucco house.

In *Ashepoo River in Spring* (ca. 1930), Cunningham invented another geographic disjunction, conjoining forms from unlike places in a whimsical coexistence. The golden fertile land refers to South Carolina, where the Ashepoo River empties into the Saint Helena Sound on the coast between Charleston and Beaufort. Towering pines, heavily laden fruit trees, wading birds, and a weathered boathouse fill the shores along a luminous mustard-yellow estuary. But Cunningham introduced a surprise in the foreground of this southern setting: a Native American rowing a birchbark canoe and wearing the regalia of a Plains or Woodlands Indian tribe.

Even when Cunningham was responding to a single locale, he could juxtapose strange and evocative elements. In *Pawley's Island* (ca. 1945; Marilyn L. and Michael A. Mennello Collection), whose title invokes a barrier island off the South Carolina coast, lavender water dotted with waterbirds and fish meanders inland between lozenges of land filled with tall pines and smaller pale-barked and leafless trees. In the foreground, the distant sailboats are echoed — as if across time as well as space — by two marvelous Norse longboats. One is under full sail (at the

Left, detail from Ashepoo River in Spring, *ca. 1930 (cat. 7)*

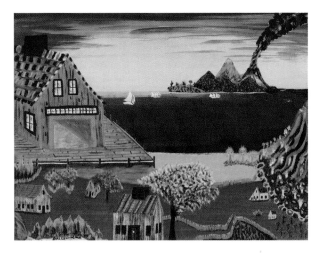

View of Volcano Island, ca. 1930 (cat. 9)

center) while the other just appears at the left. The age of the vessels and their past adventures are emphasized by their patched sails.

Florida was the inspiration for *Seminole Village, Deep in the Everglades* (ca. 1965), which transforms ethnographic detail into a decorative panorama. Under a canopy of lowering clouds, the sky breaks into brilliant crimson and gold bands. Pines cut across the fiery sunset as if they were bars marking the measures in a musical passage. Beneath the towering trees is an emerald-green lawn accented by clusters of bright yellow and orange brush and by sixteen "chickees," palm-roofed platforms on which Seminole villagers sit or recline. Rowers make their way in white boats along a chocolate-brown river that runs through the hamlet. Three robust women tend a fire in the foreground, preparing the community's evening meal.

A land of the imagination, perhaps a place Cunningham had read about, appears in *View of Volcano Island* (ca. 1930; Marilyn L. and Michael A. Mennello Collection). Here, a pale irrides-cent sky streaked with gold, red, and lavender is capped by a broad band of dark blue that echoes the inky-blue sea below. Against the bright horizon is an island filled to its wave-lapped shores with a pale blue hillock dotted with red palm trees, a triad of brown foothills enlivened by green shrubs, and a conical mountain and its volcanic companion belching a mosaic of smoke and spew-ing crimson lava down its slopes and into the sea. Despite the volcano's furious display, three ships glide complacently across the smooth sea. In the foreground is a settled land with a purple beach interrupted by golden palms growing in a little green oasis. Leading to the beach is a broad greensward filled with houses of all shapes and sizes seen from several angles and embraced by flowering trees and rows and beds of flowers. At the left is a huge ominous boathouse. Its base is a wide boardwalk that rests on piers dug into the beach, yet it also appears to float above the water. Its windowed gable echoes the distant peaks and the tile roof reiterates the island's colors. The scene provokes delight and curiosity, as we wonder why the dangerous volcano seems so benign, the yawning entry to the boathouse appears so disquieting, and there are no people enjoy-ing the welcoming houses, hospitable yards, and flowering trees.

Cunningham's intriguing images summon our own associations, recollections, fantasies, and

reveries, and they invite us to speculate about their meanings, as if we were trying to interpret our own dreams. But beyond our personal responses, we wonder which of the artist's experiences these paintings might encode or which remnants of his tantalizing dreams or visions they have retrieved. Do these idiosyncratic works reveal Cunningham's background or beliefs? What message, mood, vision of the world, or conception of art could he have meant to convey? Do his intentions, works, and spirit echo those of other artists?

Earl Cunningham, a painter who worked mostly in Maine and Florida from about 1909 until his death in 1977, was born in 1893 in Edgecomb, Maine, near Boothbay Harbor, about sixty miles from Portland.[2] His antecedents, of Scottish descent, had emigrated by way of Nova Scotia and established themselves in Maine as farmers in the early nineteenth century. The third of six children, Earl left home in 1906, at age thirteen, to make his own way in the world as a tinker and a peddler. Maine would always exercise a hold on him, and he would return to live in Boothbay Harbor for part of each year until 1937. By 1909 Cunningham was painting ships and farms on panels of salvaged wood and selling them for fifty cents. He had also begun to embark on nautical adventures; in 1909, for example, he sailed a twenty-two-foot boat to the waters around New York City, including Jamaica Bay, Sandy Hook, the Long Island Sound, and up the Hudson River. He is reported to have studied coastal navigation in 1912 and to have received a license to work as a harbor and river pilot.

Before World War I, Cunningham sailed four- and five-masted schooners carrying coal and other cargo along the East Coast from Maine to Florida. These experiences, along with family stories about the sea, provided material for his later marine paintings, as did an encounter with wildlife on the coast of Labrador, where he had gone ashore to light a bonfire to guide his schooner. About 1913 Cunningham helped repair a shackle on the J. P. Morgan family yacht, *The Grace*, and in return the skipper gave the young man a mahogany-topped white cedar canoe and lent him money to buy a sailboat. These adventures had an effect on Cunningham's art, as noted by Robert Hobbs, the author of an excellent monograph on the artist: "Cunningham's familiarity with sailing is of crucial importance to his painting, which at first memorializes his personal expe-

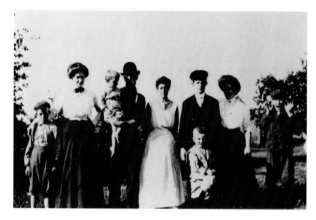

The Cunningham family, Boothbay Harbor, Maine, ca. 1917. Sixth from left: Earl Cunningham

My House Boat, *1950. Gouache on cardboard*

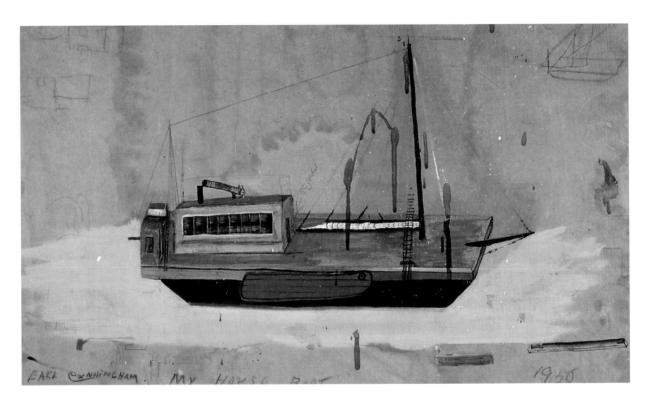

riences, then celebrates the survival of this impressive industry, and finally pays tribute to the passing of commercial shipping at the same time that it takes pleasure in the increasingly popular sport of sailing."[3]

In 1915 Cunningham married Ivy Moses ("Maggie") and bought a thirty-five-foot cabin cruiser that he called the *Hokona*. That year the couple first visited Saint Augustine, Florida, which would later become the painter's home. Between 1918 and 1940 the Cunninghams divided their time between Florida and Maine, making trips to Ohio, Georgia, and South Carolina. They earned a living digging for Indian relics, catching and selling fiddler crabs and coral, running a sawmill, and farming, while Cunningham continued to paint. Sometime after 1936 the couple was divorced. By 1940 Cunningham had decided to create a museum of one thousand of his own

paintings, and in 1949 he moved to 51–55 Saint George Street in Saint Augustine and established the Over-Fork Gallery. His landlady, Theresia (Tese) Paffe, became his patron, close friend, and personal and professional mainstay. In the gallery Cunningham kept a stock of brass fittings for ships, bottles, hardware, old greeting cards, and all sorts of antiques and odds and ends, and he allowed certain visitors to view his paintings in the adjacent storefront museum. He became an eccentric, prickly, and irascible shopkeeper, the notorious "crusty dragon of Saint George Street,"[4] who was likely to turn away customers even when the gallery was open and was resistant to selling the paintings that he begrudgingly permitted a lucky few to see.

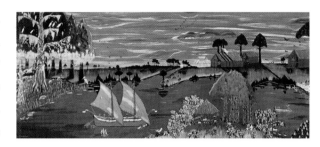

The Everglades, *ca. 1950 (cat. 26),*
John F. Kennedy Library and Museum, Boston

About 1950 Cunningham painted twenty pictures of Native Americans (now lost) for the Michigan Historical Society and began to show his work in local exhibitions in Florida. In January 1961 he sent *The Everglades* (ca. 1950; John F. Kennedy Library and Museum, Boston) to Jacqueline Kennedy at the White House and received thanks in May through her secretary, Letitia Baldridge. He identified himself as a "Primitive Artist" on his 1968 business card. In 1969 Marilyn Logsdon Wilson (now Mennello) and her friend Jane Dart discovered Cunningham's work, and the artist reluctantly allowed them to purchase paintings from him.

As a result of Marilyn Mennello's enthusiasm for Cunningham, he had his first one-man exhibition, in summer 1970, at the Loch Haven Art Center in Orlando (now the Orlando Museum of Art). More than 200 of his paintings were included in a show at the Museum of Arts and Sciences, Daytona Beach, in August 1974. On August 15, 1975, he could count in his possession 330 pictures, "all in frames," and on June 3, 1976, he noted that 405 paintings were "on hand now." Despite such increasing recognition and prolific production, Cunningham shot himself to death on December 29, 1977. In the last twenty years, his works have appeared in numerous exhibitions and have excited critical and scholarly appreciation; Hobbs' monograph was published in 1994.

Cunningham's paintings distill experiences from his adventurous, resourceful, and varied life — in New England, seafaring towns on the East Coast, rustic locales in the Midwest, and tropical Florida — and in a sense are thus a complex personal travelogue. In the emblematic *View from the Widow's Walk*, we travel not just through space but through Cunningham's life, between New

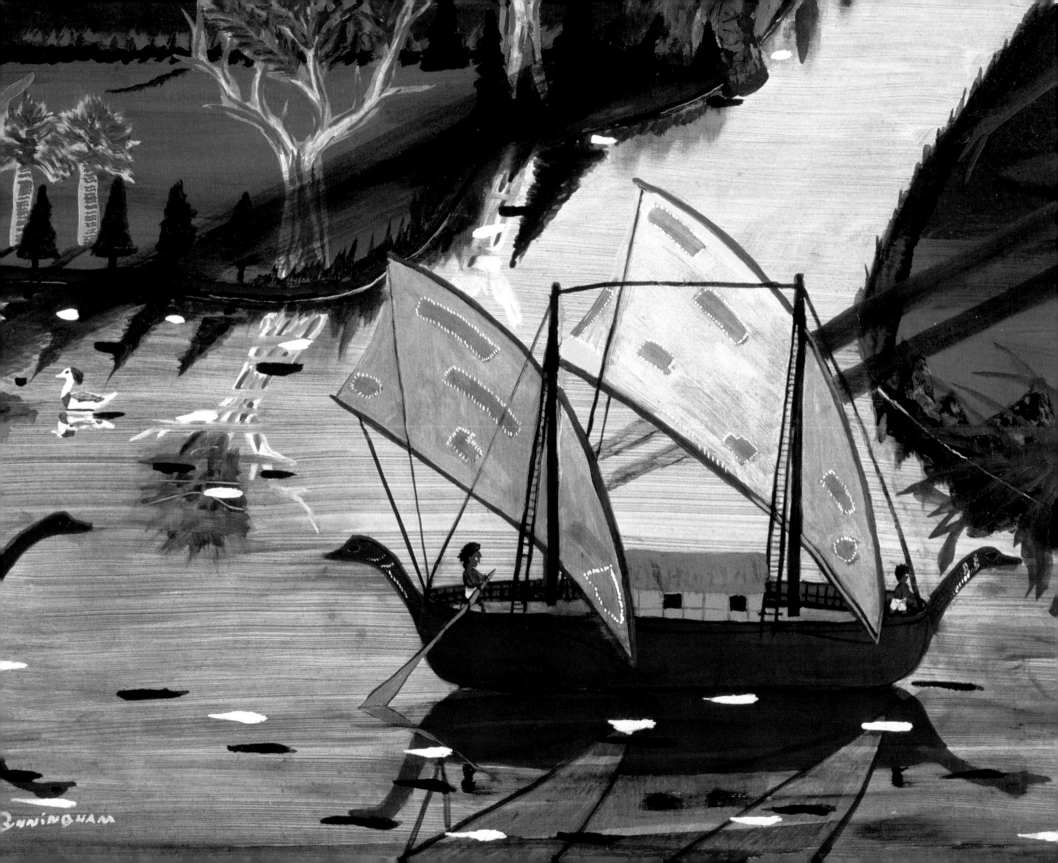

England and Florida, where he moored himself both early and late. *Ashepoo River in Spring* and *Pawley's Island* refer to his visits to South Carolina, and *Seminole Village, Deep in the Everglades*, like many other works, reflects his connection to Florida.

But as Cunningham mined and recombined the actual and the invented, the past and the present, the imagined and the desired, he was selective. Believing that "life is simple and fun if you let it be,"[5] he created safe harbors for his own spirit in his paintings and invited viewers to share them. In the face of the accelerated pace of the twentieth century, he celebrated an unspoiled America filled with poetic and nostalgic pre-industrial places, people, and things: Norse explorers in their longboats, old coastal sailing vessels, pleasure craft, Native Americans, tiny homesteads in bucolic landscapes, and the houseboats he coveted. His paintings suggest an agreeable and redemptive future and act as visual metaphors for the profound feelings embodied in traditional American songs, such as "Sweet By-and-By":

> *There's a land that is fairer than day,*
> *And by faith we can see it afar;*
> *For the Father waits over the way,*
> *To prepare us a dwelling place there.*
>
> *In the sweet by-and-by,*
> *We shall meet on that beautiful shore,*
> *In the sweet by-and-by,*
> *We shall meet on that beautiful shore.*[6]

Cunningham's simple Edenic world was complemented by his apparently simple style. Yet Cunningham was a sophisticated naïf, a self-taught artist who made carefully considered choices of materials, forms, and compositions. He almost always painted on Masonite panels — perhaps out of convenience, or to accommodate his peripatetic habits, or to ensure that his works would

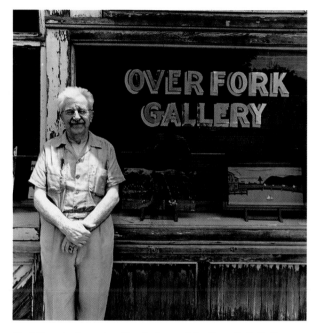

Earl Cunningham standing in front of the Over-Fork Gallery, 1970. Photograph by Jerry Uelsmann

Left, detail from Pawley's Island, *1945 (cat. 20)*

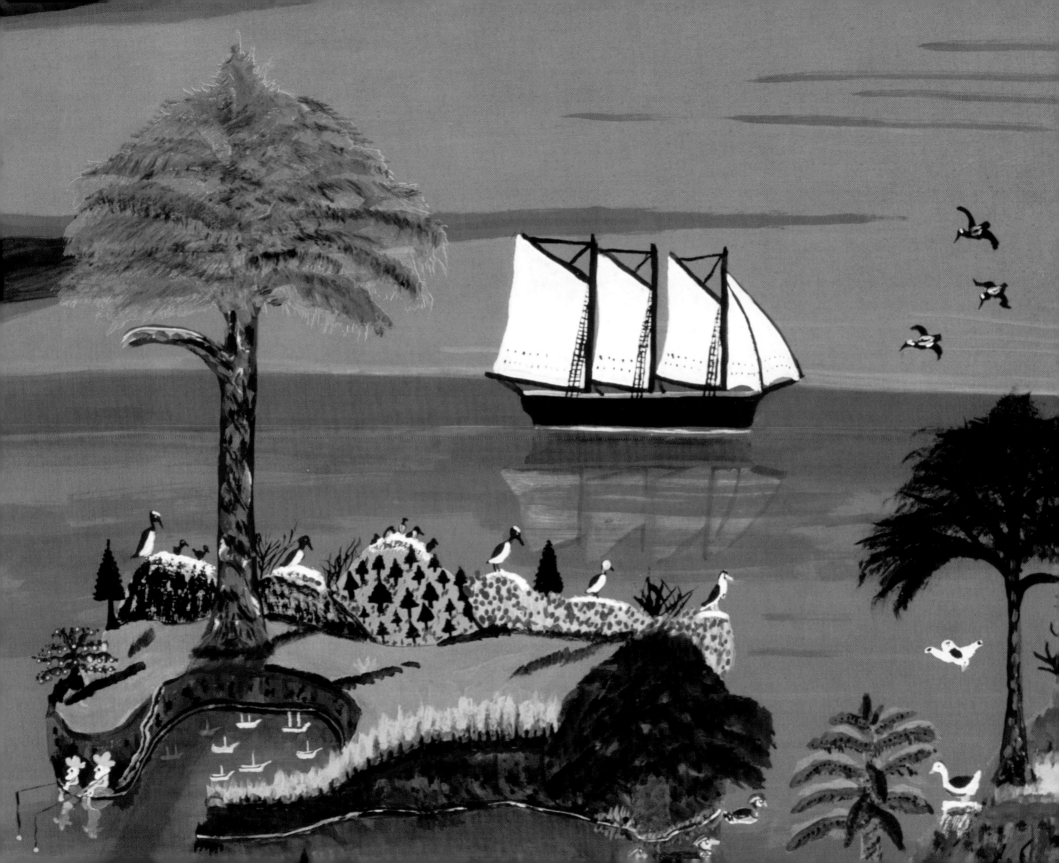

last, or because the clear and simple forms he created would be most legible on the smooth man-ufactured surface. He used professional artist's pigments, some commercial enamels, and glossy varnishes, all of which make his painted forms seem to dazzle like visions in a dream. He also used various artists' tools and additives to create textures — for example, the rough bark on the trees in *Seminole Everglades* (ca. 1945; The Metropolitan Museum of Art, New York). Cunningham almost always designed, cut, painted, and varnished pine or cypress frames that are stylistically consistent with the peculiar visual language of his paintings and thus can enhance his works more than any commercial frames.

A remarkable colorist, Cunningham exploited a vibrant, arbitrary, and decorative palette to describe his audacious, intuitive vision of the world and to suggest its unspoiled freshness. He was as willing to paint any of his stylized seas, rivers, swamps, or inlets a warm rich brown as he was to depict them in citron yellow, blazing crimson, or cotton-candy pink. His strong unmodulated colors suggest the influence of animated cartoons, such as Walt Disney's *Snow White and the Seven Dwarfs* (1937) or *Fantasia* (1940), as well as the works of Paul Gauguin (1848–1903), the Symbolists, and the Fauves, whose aesthetic had been assimilated into popular imagery.[7] A review-er for the *New York Times* agreed: "Cunningham's is a verdant earthly paradise, all the more amazing for being set in a modernist monochrome lighted by Disney."[8] Popular items also may have served as resources for Cunningham; garish chromolithographs, souvenir plates, and print-ed textiles could have been part of the inventory of the Over-Fork Gallery.[9] The colors of Florida's stucco architecture might have inspired and reinforced the instincts of this imaginative colorist who often implicated color in the titles of his paintings: *Red Sky over Folly Beach* (1975; Marilyn L. and Michael A. Mennello Collection), *Seminole Village, Brown Water Camp* (1950), *Seminole Village with Lavender Sky* (ca. 1963; Lightner Museum, Saint Augustine).

While many of Cunningham's paintings may be dated, his stylistic development is complicat-ed. As Hobbs has noted, his works from the 1920s and 1930s tend to rely on small formats and relatively subdued colors; they portray wide prospects with many small figures. Later, Cunningham preferred larger formats, stronger and more saturated hues, and closer views of his

Detail from Seminole Everglades, *ca. 1945 (cat. 21)*
The Metropolitan Museum of Art, New York

Left, detail from Red Sky Over Folly Beach, *ca. 1975 (cat. 49)*

31

American Bald Eagle. *Painted wood sculpture*

folk painters who are the descendants of this tradition: Edward Hicks (1780–1849), whose portrayals of the Peaceable Kingdom anticipate Cunningham's Edenic views of America; Erastus Salisbury Field (1805–1900), whose biblical scenes display the same multiplicity of details, distorted perspective, abstract patterning, and startling color contrasts that appear in Cunningham's *Sanctuary* (ca. 1934); Jurgan Frederick Huge (1809–1878), who, like Cunningham, delighted in enumerating the specifics of buildings and ships. The works of a later generation of self-taught artists also resonate in Cunningham's art. Joseph Pickett (1848–1919), who ran a general store in New Hope, Pennsylvania, and John Kane (1860–1934), who produced memorable images of Pittsburgh when it was a developing metropolis, created paintings that are akin to Cunningham's *Mountain Trains* (ca. 1940), for example. Anna Mary Robertson Moses, known as "Grandma Moses" (1860–1961), in particular, was an obvious counterpart of Cunningham. He studied her works and regarded her as "important but not daunting competition."[13]

Deeply patriotic, Cunningham may have been aware of and sympathetic to the increased cultural nationalism of the 1920s and 1930s, when an aversion to foreign impulses that developed in the wake of World War I provoked a search for a reassuring American past. This desire prompted the reevaluation of many aspects of American art, including folk and vernacular idioms, whose revival was conspicuous around Ogunquit and Boothbay Harbor, Maine. Renewed interest in American folk art was reinforced by a concurrent appreciation of antinaturalistic modernist tendencies in painting. As a result, dealers such as Edith Halpert and curators such as Holger Cahill promoted modernism and the folk-art revival simultaneously.[14]

Cunningham's efforts also call to mind those of mainstream American painters. Like Thomas Cole (1801–1848), whose work he may have known firsthand or through prints, Cunningham tended to paint works in series. He responded to a hurricane that devastated Florida in 1970 with a group of three canvases: *Hurricane Warning, Big Storm,* and *The Hurricane* (all ca. 1970). His earlier *Seminole Everglades* and *Tranquil Forest* (ca. 1933) may also be seen as a pair. Both paintings portray pine trees silhouetted against a brilliant gold sky and water, and groves enlivened by birds in the air, on the ground, and in the water. *Tranquil Forest* includes a cut tree whose branch-

es set off owls, ducks, and flamingos. Cunningham may have been aware that Cole and other Hudson River School artists depicted such emblematic cut trees to suggest the cost of progress.

Cunningham's descriptions of the rigging of his cargo-bearing schooners bring to mind the works of the great marine painter Fitz Hugh Lane (1804–1865) and of the prolific twins James (1815–1897) and John Bard (1815–1856), who created more than four thousand paintings of steamboats and sailing vessels that were reproduced by Currier and Ives. More poetic than Lane or the Bards, and therefore even closer in spirit to Cunningham, is the work of Albert Pinkham Ryder (1847–1917), who, like Cunningham, grew up in coastal New England and shared a passionate desire to realize, in paint, an inner vision of the sea and a willingness to ignore naturalistic appearances. The mystical quality of Cunningham's *Midnight Cruise*, with its constellations of stars, trees, and waterbirds, and the extraordinary anthropomorphic rain clouds of *Old Thunder Cloud* (ca. 1962) bring to mind similar devices in Ryder's paintings.

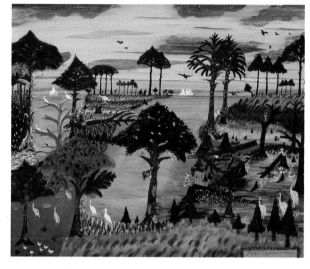

Sanctuary, ca. *1933 (cat. 11)*

Marsden Hartley (1877–1943), who centered his art on yearly visits to Maine after 1937 and emulated Ryder's approach to nature, tried to project his innermost feelings for the land by inventing powerful Expressionistic forms. Hartley's blocky mountains, rugged waterfalls, and ominous skies have a visual and spiritual counterpart in the sturdy trees and undulating storm clouds in Cunningham's *Old Thunder Cloud*. Like Hartley, Charles Burchfield (1893–1967) was fascinated with nature and often used anthropomorphic elements to embody the lyricism, mysticism, and power that he perceived in the woods, fields, and streams of his surroundings. Burchfield's invigorated natural elements are akin to the activated clouds and trees in Cunningham's *Old Thunder Cloud* and *Ashepoo River in Spring*.

Cunningham's art shares qualities of that of mainstream modernists who renounced academic rules of naturalistic painting. The arbitrary, saturated colors and flattened space of *Tranquil Forest*, for example, invoke the canvases of Vincent van Gogh (1853–1890). The picture-puzzle complexity of the arrangement of flattened shapes in *Sanctuary* (ca. 1934) is analogous to the neo-Impressionist compositions of Georges Seurat (1859–1891), who also emphasized the decorative quality of his paintings by designing frames for them. Some of Cunningham's intricate

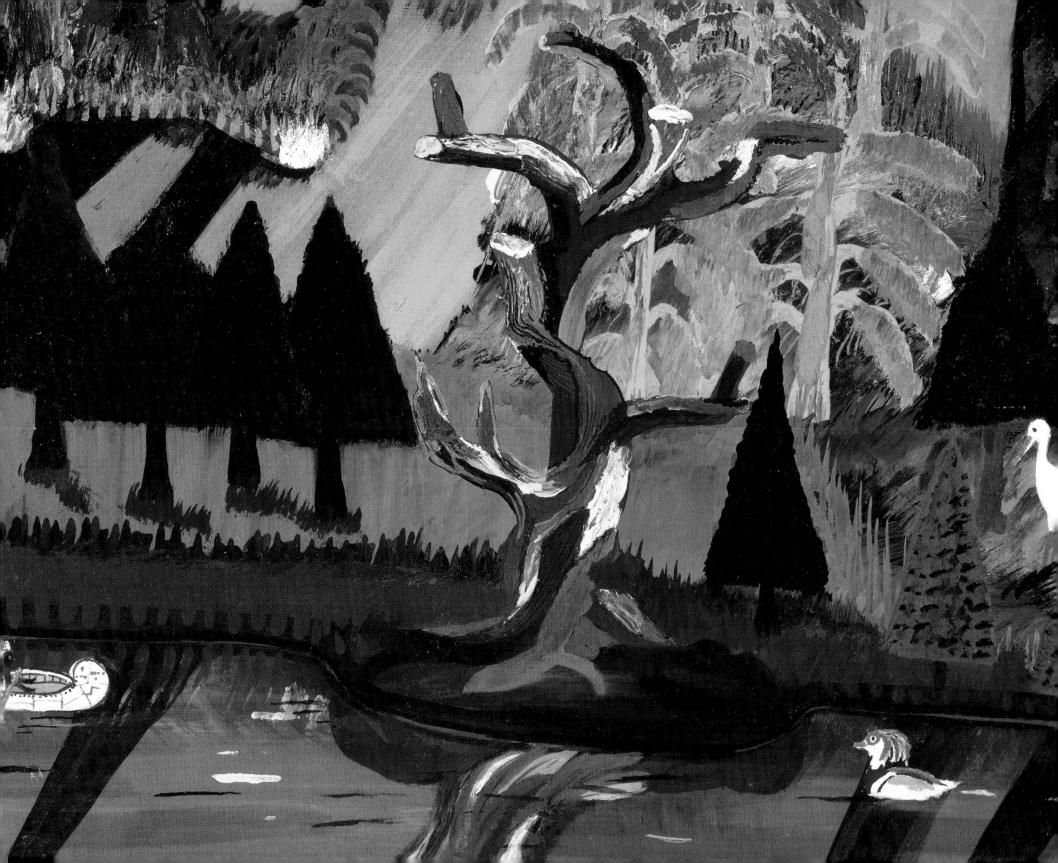

subjects. There are, however, exceptions to these generalizations and many instances in which the artist quoted his earlier style in subsequent works.[10]

The flatness of Cunningham's subjects, their arbitrary scale, and their canonical frontal or profile views result from his lack of formal training. His clouds are sinuous and conventionalized; his vessels sail parallel to the picture plane; his flowers, trees, birds, fish, people, and animals could have been drawn by a child. His indifference to one-point perspective is also typical of an artist who was detached from academic practices. Cunningham always gauged the ground plane from a bird's-eye view. Because his command of spatial recession was unreliable, his volumetric buildings seem suspended rather than affixed to the ground. He preferred a high horizon that is sometimes curved, perhaps reflecting his experience as a seaman. His compositions are often constructed according to varying symmetries: left to right, top to bottom, mirroring diagonals.[11] The paintings seem like delightful diagrams whose abstract harmonies imply that iconic, universal statements about the world can be distilled from random experience.

Shadowbox frame and painting by Earl Cunningham

While Cunningham was self-taught and not bound by tradition and his gallery was not a venue for the display of mainstream art, he did function in a context associated with the commercial art world. He treated the gallery space that he devoted to his paintings as a "museum" and tried to keep his works together as a collection.[12] He was seemingly aware of the art world in general, though it is difficult to determine exactly what he knew and when and how he acquired that knowledge.

At the very least, Cunningham was a kindred spirit of artists of the past and of his own time who cherished the images of the mind's eye, who relied on concepts rather than perception: cave painters of Lascaux who used art to reaffirm their relationship with their desires, adventures, and dreams; painters of ancient Egypt who recorded the present for an even-greater hereafter; medieval designers who translated biblical stories into stained glass for those who could read only pictures; and limner portraitists of colonial America who eternalized their sitters in iconic images. Cunningham's itinerancy specifically links him to the limner tradition, and the construction and simplified forms in a work such as *Midnight Cruise* (ca. 1955) invoke the limners' coach decorations, sign boards, and overmantels. His style also recalls that of the nineteenth-century American

Left, detail from Tranquil Forest, *ca. 1933 (cat. 10)*

Earl Cunningham holds one of his paintings in his gallery

compositions and arbitrary color schemes recall works by Maurice Prendergast (1859–1924), who applied patches of pigment as if they were tesserae of mosaic and who had his works framed decoratively by his brother Charles (1869–1948). The abstract pattern in the sky of Cunningham's *Seminole Village, Deep in the Everglades* brings to mind similar devices in works by Edvard Munch (1863–1944) and the ambiguous pathways in the same painting echo Expressionistic street scenes that Wassily Kandinsky (1866–1944) created in the early 1900s. Cunningham's distortions of scale are familiar traits of the work of Pablo Picasso (1881–1973), and his exuberant palette aligns him with the passionate colorists Henri Matisse (1869–1954), Maurice de Vlaminck (1876–1958), and the other Fauves. Hobbs has suggested that Cunningham's tendency to paint groups of works based on specific sites (the Everglades, the Carolinas, or Florida), subjects (lighthouses), or color schemes is not unlike the practice of Robert Motherwell (1915–1991) and Frank Stella (b. 1936), whose works he might have known through local artists.[15]

Cunningham may have learned about modern art from magazines, or from reproductions that might have been part of the stock of the Over-Fork Gallery, or from conversations. Whether or not he was actually aware of particular antecedents or contemporaries, he shared the desire for originality, directness, and authenticity of many mainstream twentieth-century painters, some of whom had reinvigorated their own work by studying tribal art, children's art, and the art of the self-taught. Cunningham's paintings invite us to take a curious, refreshing, and delightful voyage through time and space, through the realms of experience and the imagination. They stimulate the eye as well as the memory. They provoke appreciation for the vision of their creator and for the faith and devotion of Marilyn and Michael Mennello, who have gathered, preserved, and chosen to share them with us. ➤

H. Barbara Weinberg is the Alice Pratt Brown Curator of American Paintings and Sculpture at The Metropolitan Museum of Art, New York.

Essay Notes

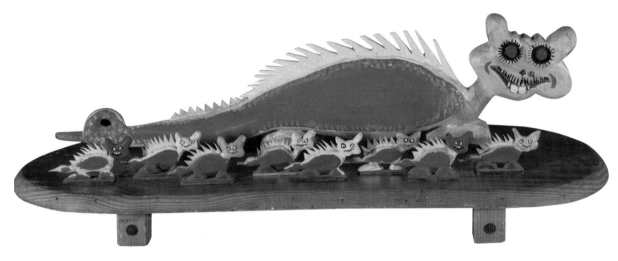

Dragon and Eight Babies, *1974. Painted wood sculpture on stand*

1. Unless specified, all works mentioned are in the collection of The Mennello Museum of American Folk Art, Orlando, Florida.

2. For biographical information on Cunningham, see Robert Hobbs, *Earl Cunningham: Painting an American Eden* (New York: Harry N. Abrams, 1994), pp. 137–38. Hobbs' monograph, which includes an excellent bibliography, has been a key resource for the author.

3. Ibid., p. 68.

4. Cynthia Parks, "The Crusty Dragon of Saint George Street," *Times-Union and Journal Magazine* (Jacksonville, Fla.), August 20, 1972.

5. Cunningham to Marilyn Mennello, November, 1969.

6. Joseph P. Webster, "Sweet By-and-By," from Joe Mitchell Chapple, ed., *Heart Songs Dear to the American People* (Cleveland and New York: World Publishing Company, 1950), p. 485. The author wishes to thank Peter Bartis, Folklife Specialist, American Folklife Center, Library of Congress, Washington, D.C., for his assistance.

7. Hobbs, *Cunningham*, pp. 40, 44.

8. Roberta Smith, "Earl Cunningham and Grandma Moses: Visions of America," *New York Times*, February 17, 1995, p. C30.

9. Hobbs, *Cunningham*, p. 59.

10. Ibid., p. 89.

11. Ibid., p. 51.

12. Ibid., pp. 18, 20–21.

13. Ibid., p. 18, citing a 1993 telephone interview with Charles Brigham.

14. Ibid., p. 102.

15. Ibid., p. 99.

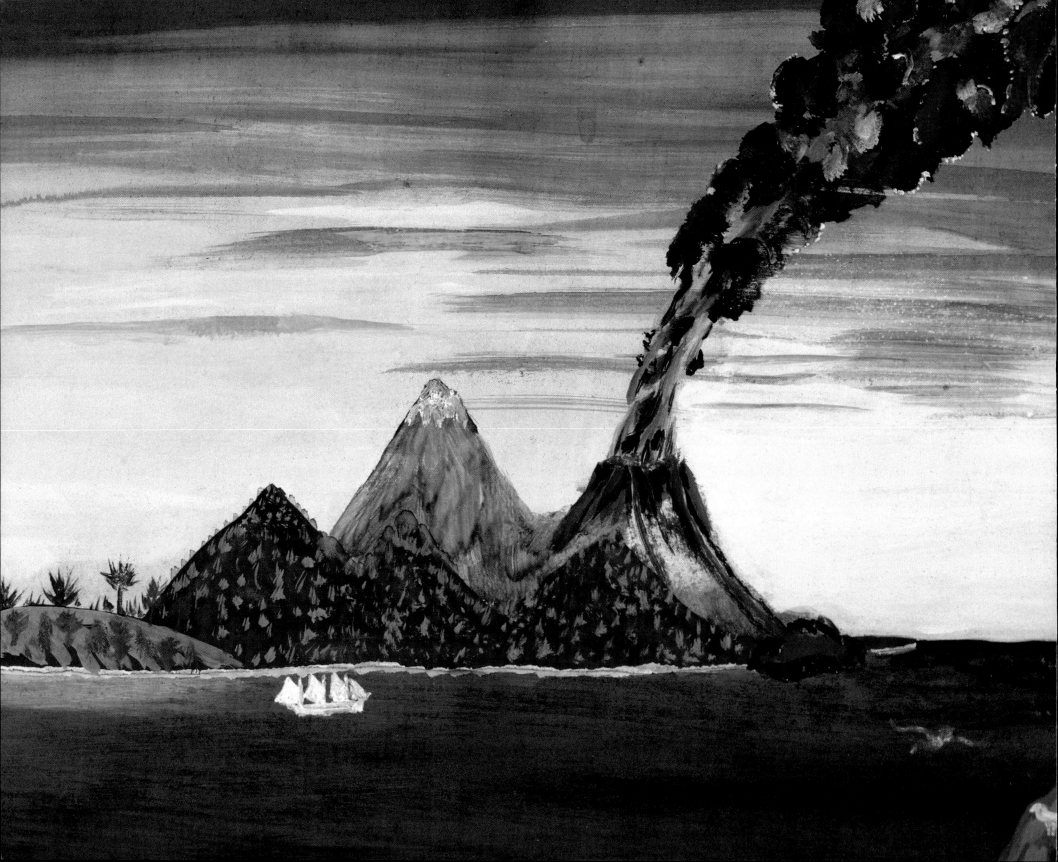

Color Plates

Archangel Gabriel(s). *Painted wood sculpture*

Left, detail from View of Volcano Island, ca. 1930 *(cat. 9)*

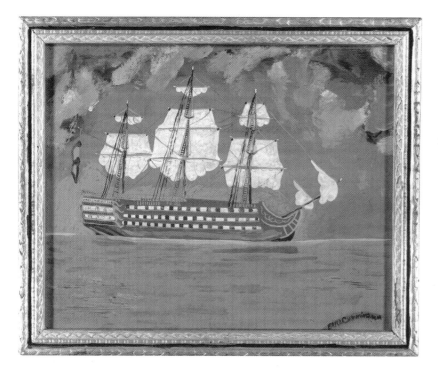

1. Stratton Island, *1914*

2. Delightful Day at Blue Bay, *ca. 1925*

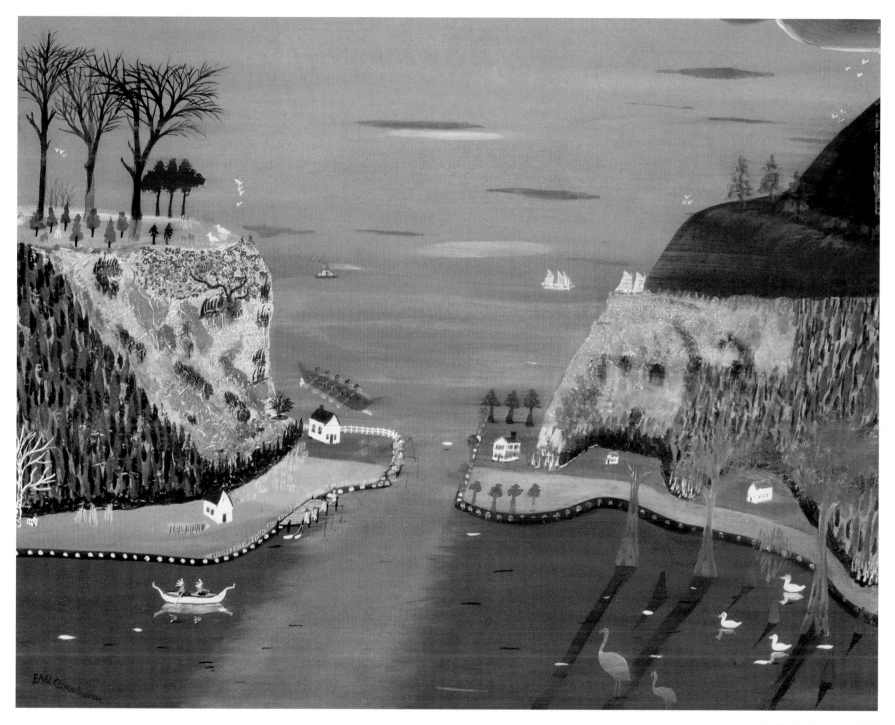

3. Windy Cove, ca. 1925

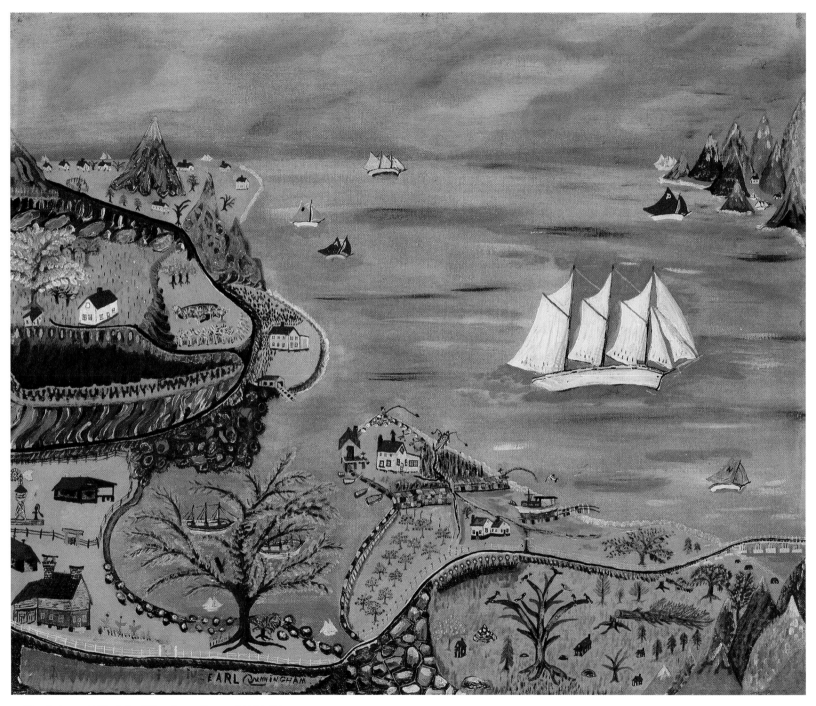

4. Untitled, *ca. 1928, Gift of Mrs. Justin Dart to M.M.A.F.A.*

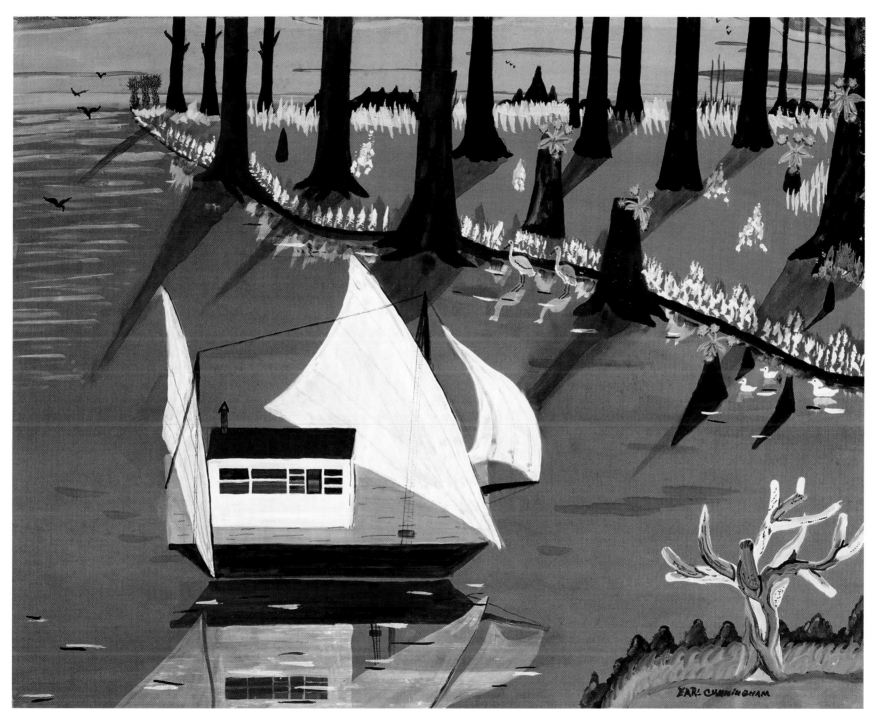

5. Houseboat on Flamingo Bay, *ca. 1926, High Museum of Art, Atlanta*

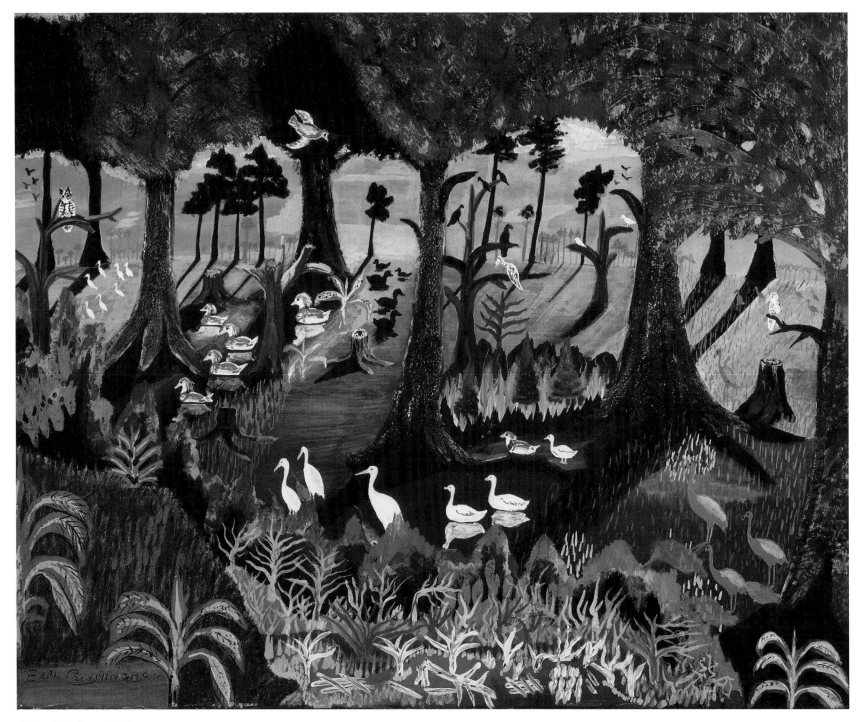

6. Marsh Birds, *ca. 1928*

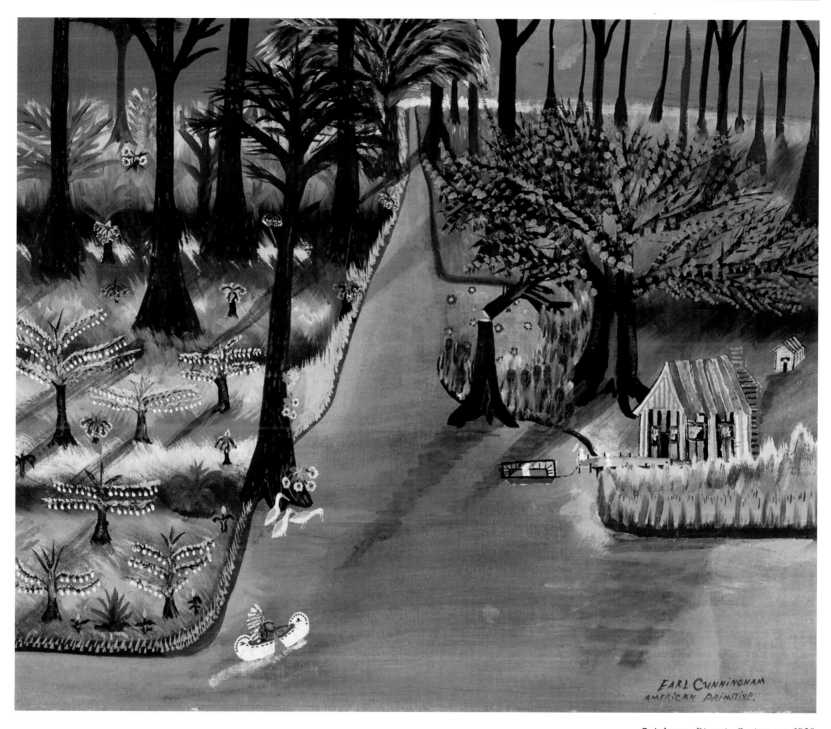

7. *Ashepoo River in Spring, ca. 1930*

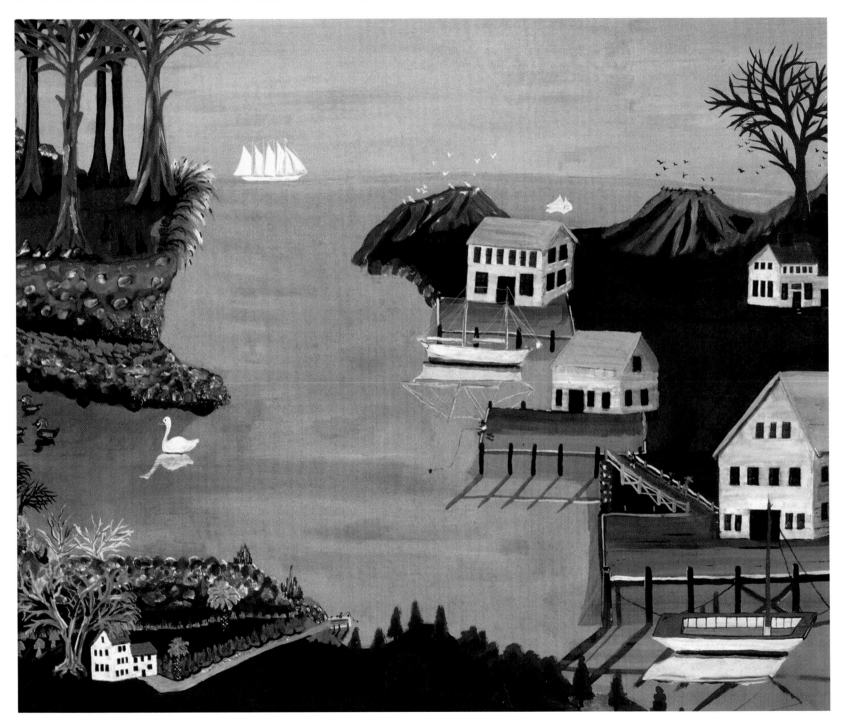

8. Town on Pleasant Point, *ca. 1930*

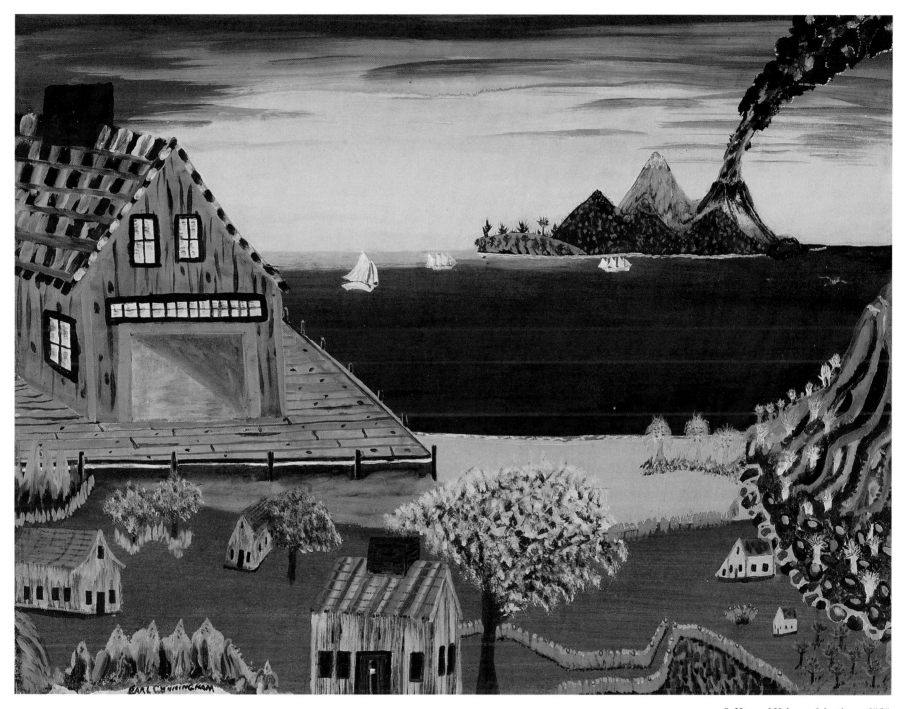

9. View of Volcano Island, *ca. 1930*

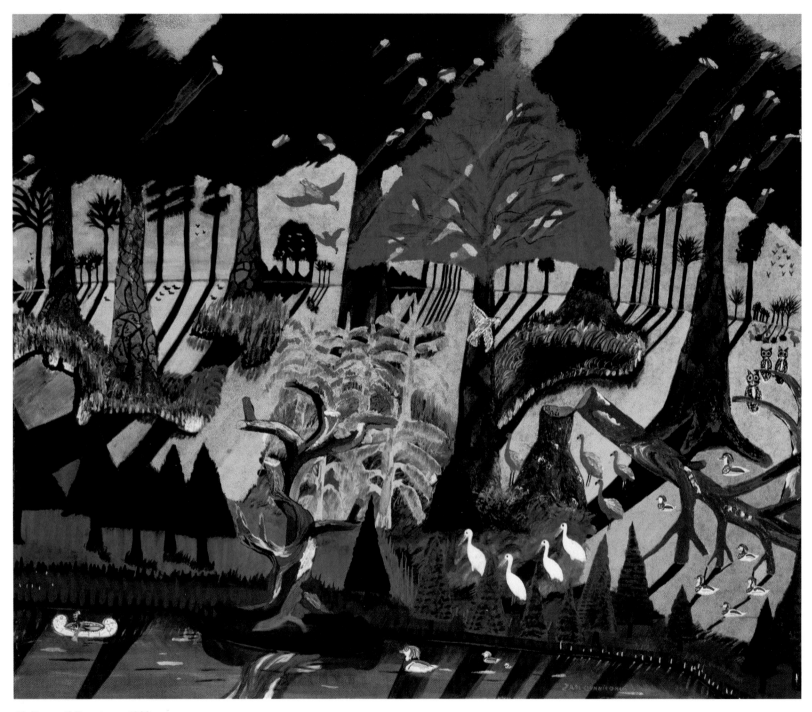

10. Tranquil Forest, *ca. 1933*

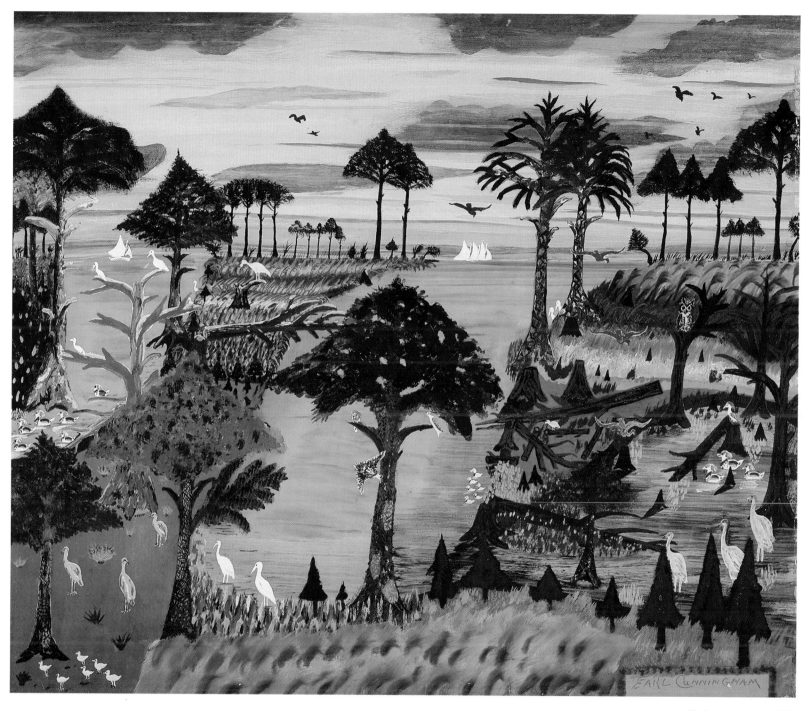

11. Sanctuary, ca. 1933

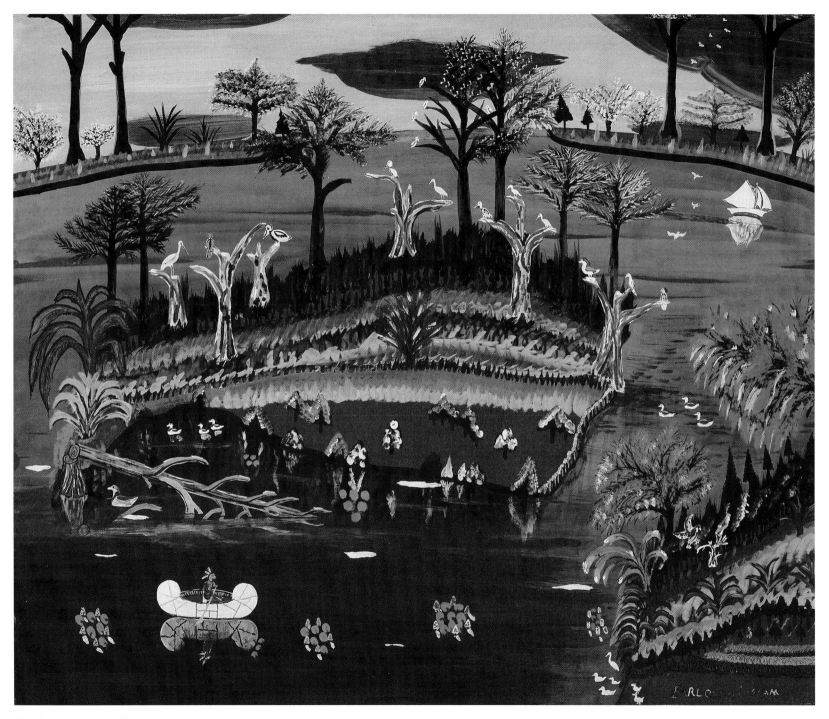

12. Island Farm, *ca. 1935*

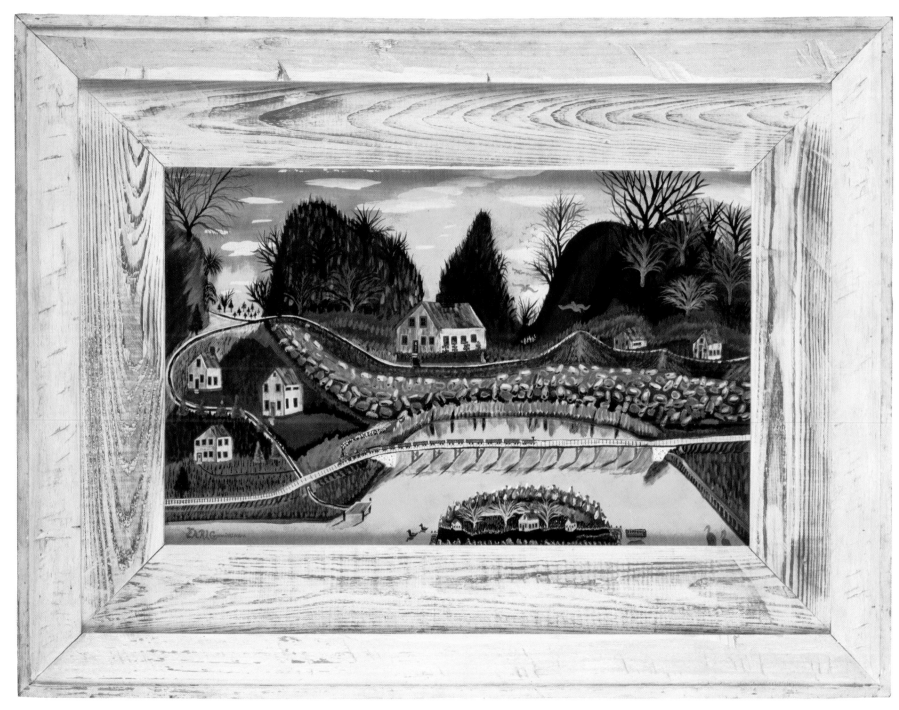

13. Valley Freight Train, *ca. 1938*
Abby Aldrich Rockefeller Folk Art Center, Williamsburg

14. Old Mill House, *ca. 1938*

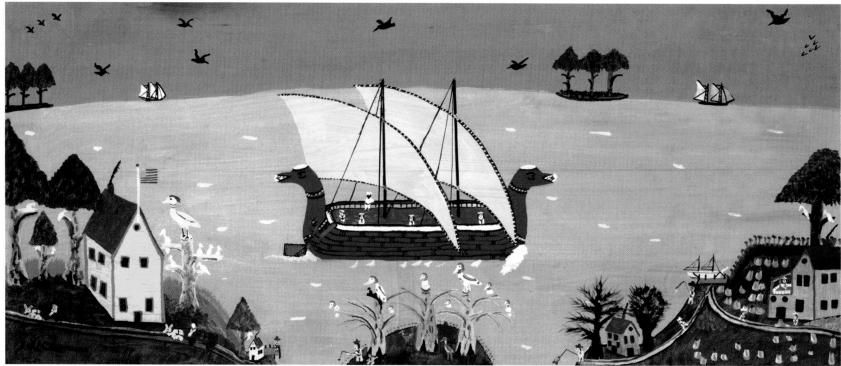

15. Red Viking Portrait, *ca. 1938*

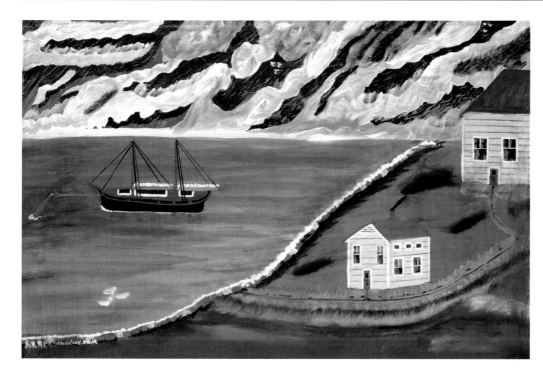

16. Icy Harbor, ca. 1940

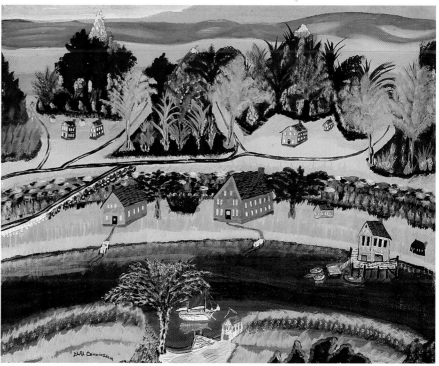

17. River Camp, ca. 1940

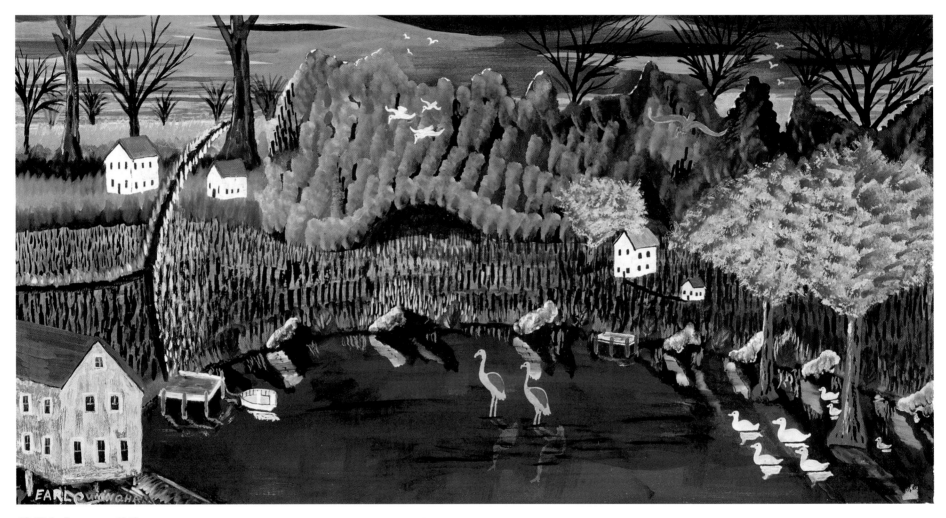

18. Night Scene, ca. 1940

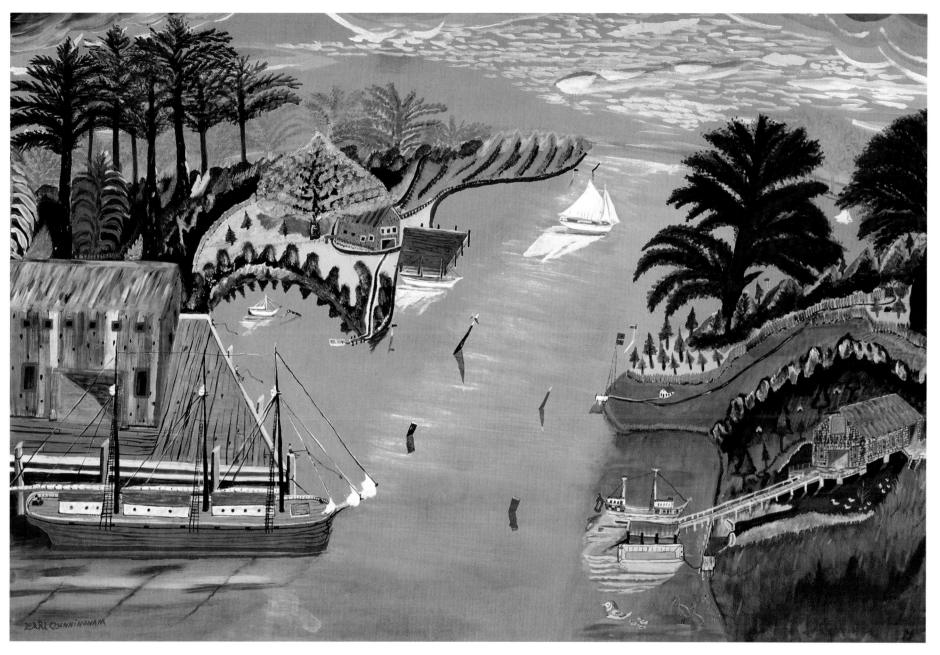

19. Squirrel Hollow, *1940*

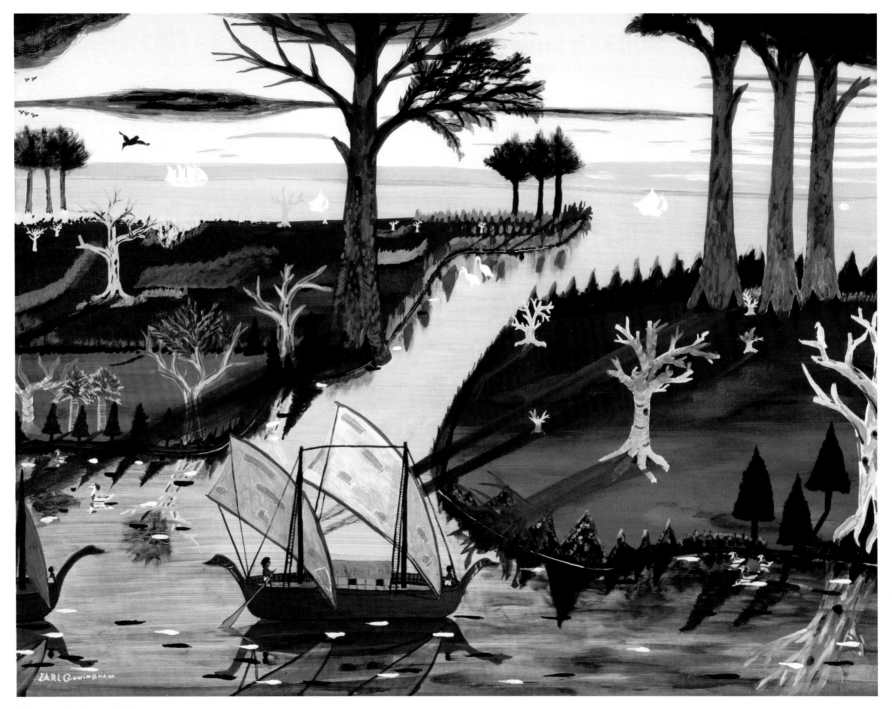

20. Pawley's Island, 1945

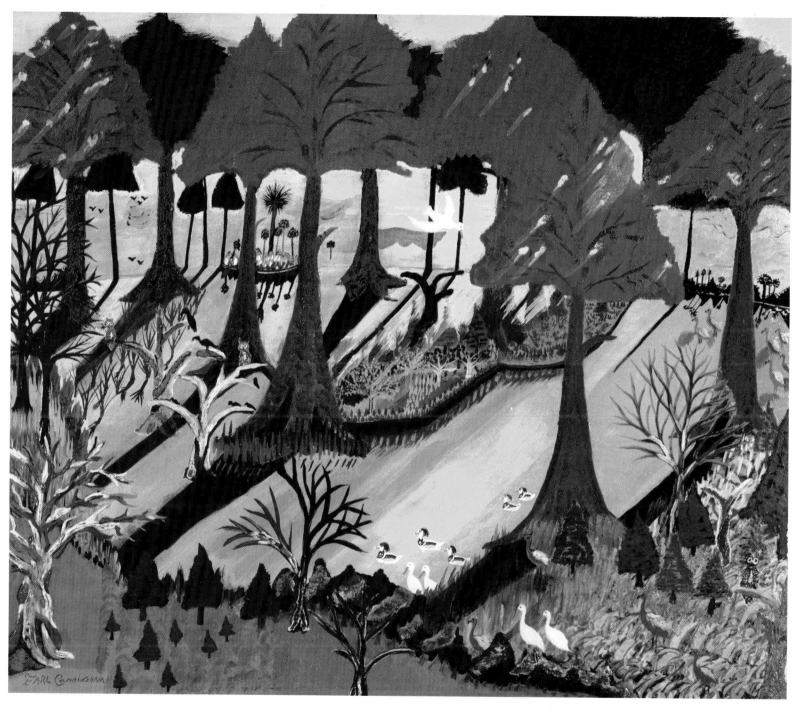

21. Seminole Everglades, *ca. 1945*
The Metropolitan Museum of Art, New York

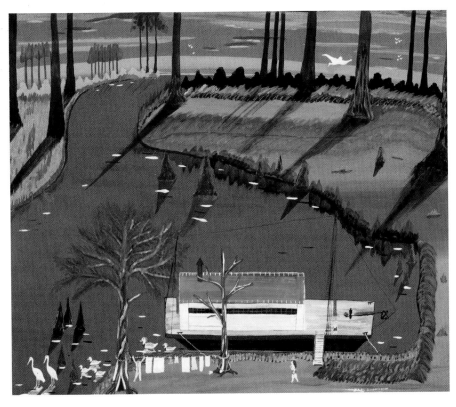

23. Houseboat at Oyster Key, *ca. 1945*

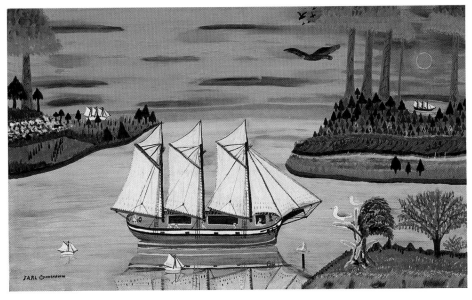

24. Reflections, *ca. 1945*

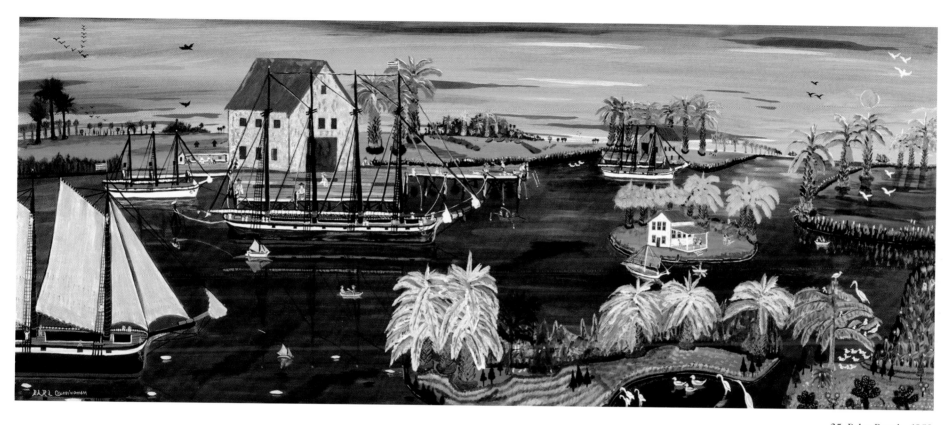

25. Palm Beach, *1950*

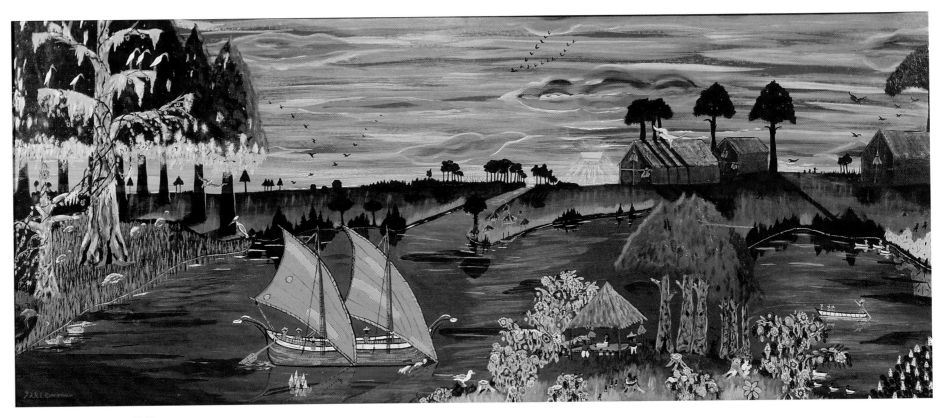

26. The Everglades, *ca. 1950*
 John F. Kennedy Library and Museum, Boston

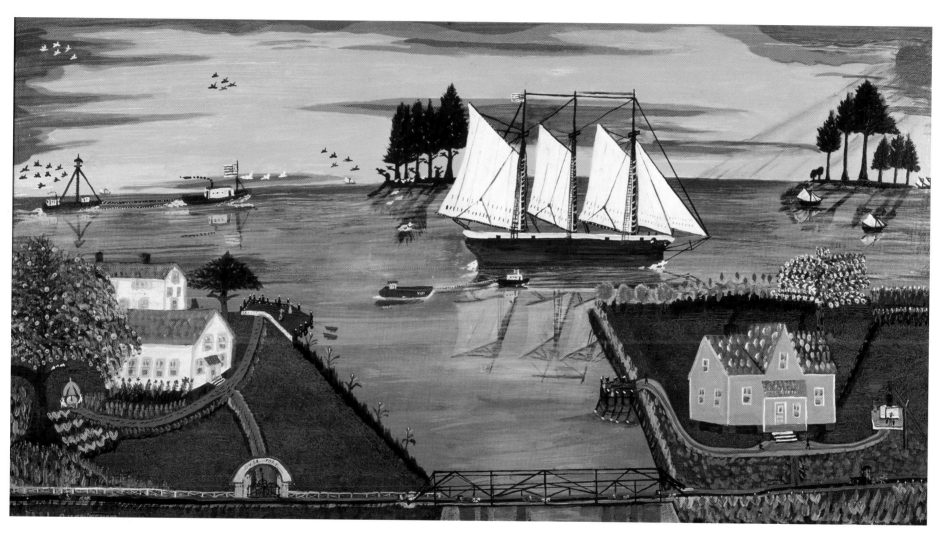

27. Summer Day at Over-Fork, *ca. 1950-55*

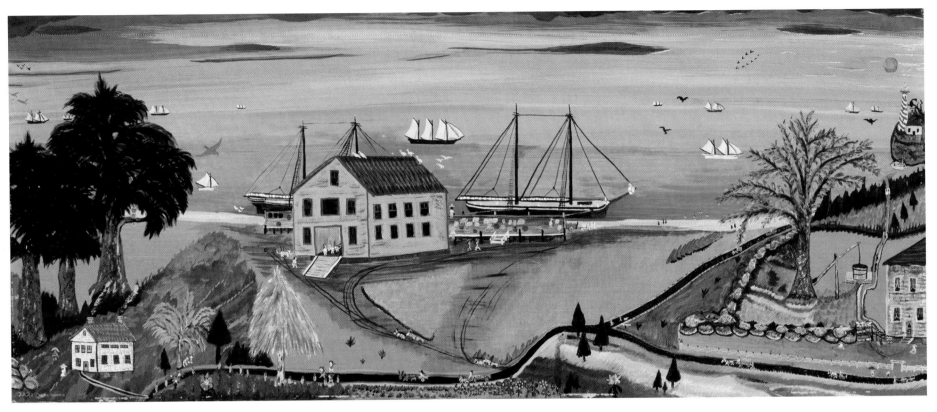

28. Warehouse at Hokona Settlement, *ca. 1950*

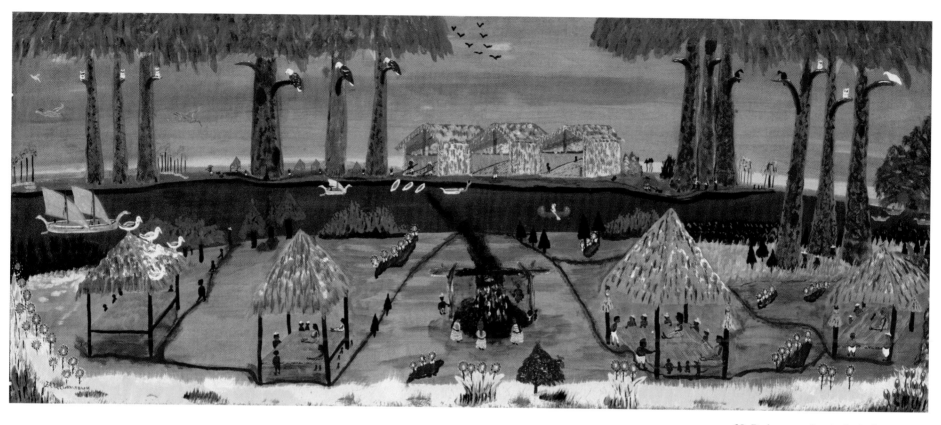

29. Barbeque — Seminole Style, ca. 1955

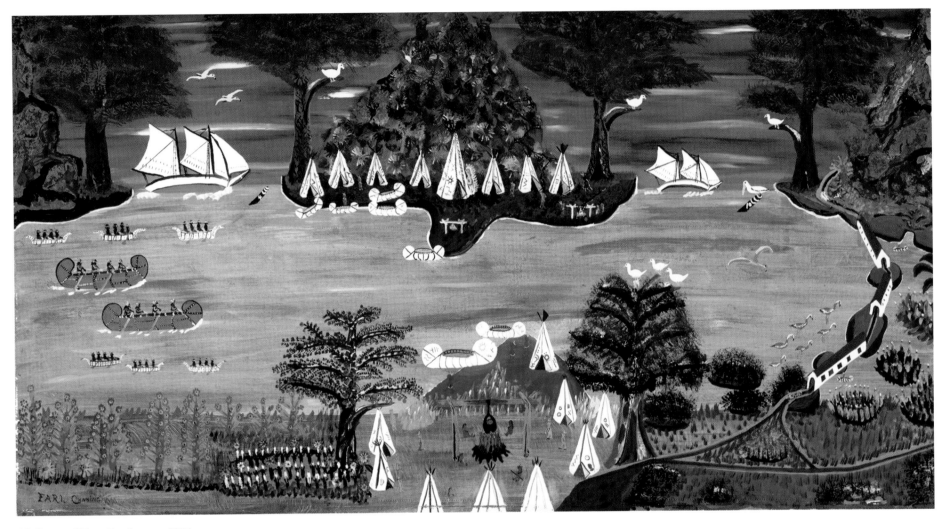

30. Visiting White Tee Pee, *ca. 1955*

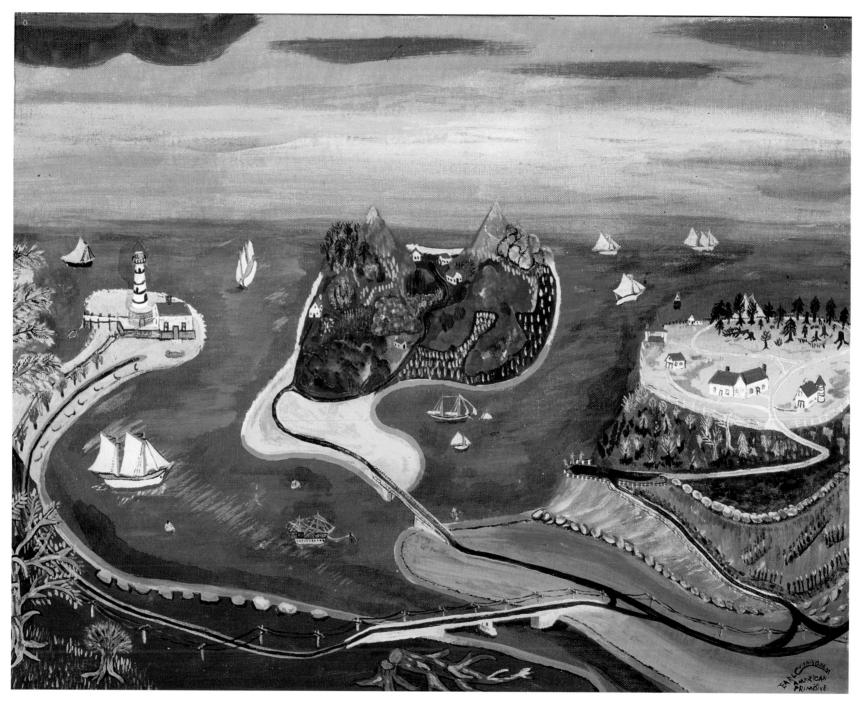

31. New England Landscape, ca. 1955
Orlando Museum of Art, Florida

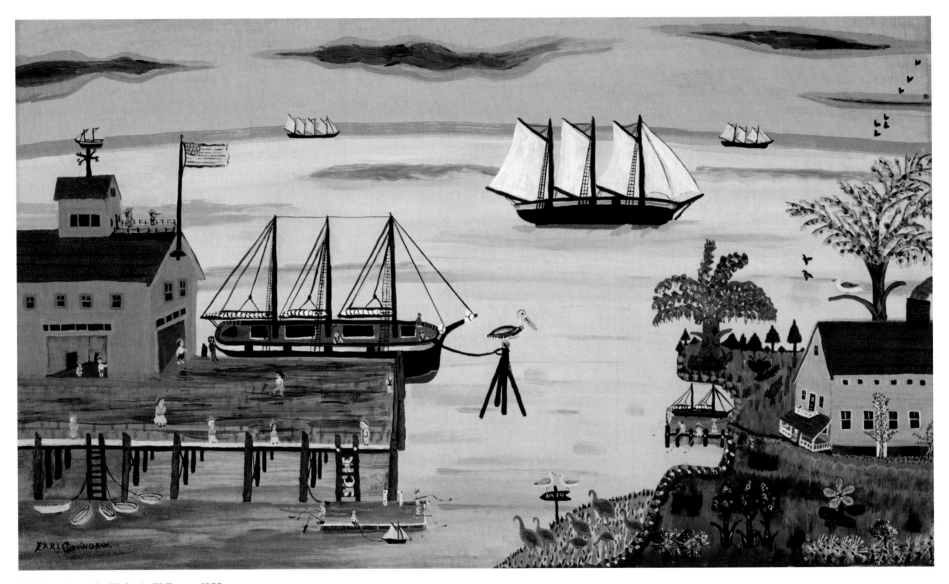

32. View From the Widow's Walk, *ca. 1955*

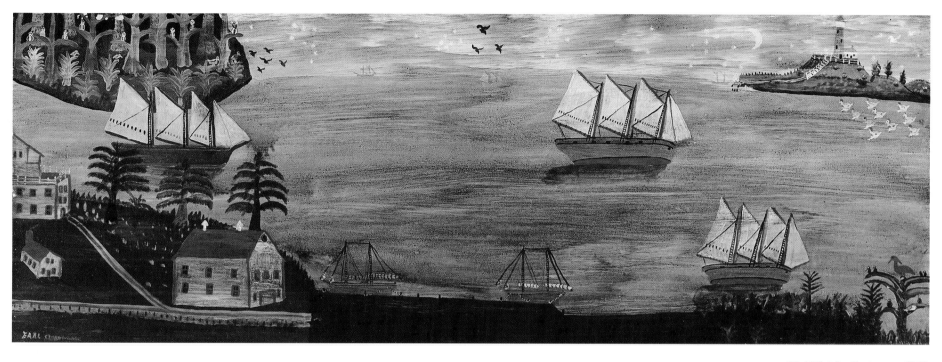

33. Midnight Cruise, ca. 1955

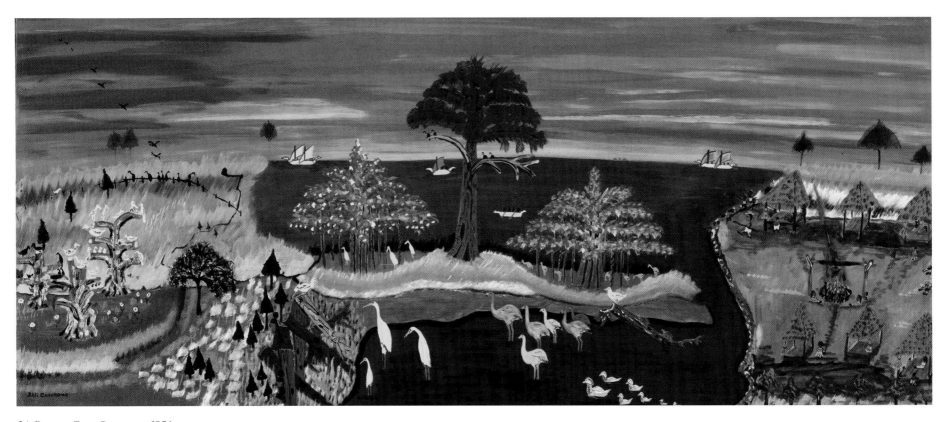

34. Banyon Tree Camp, ca. 1956

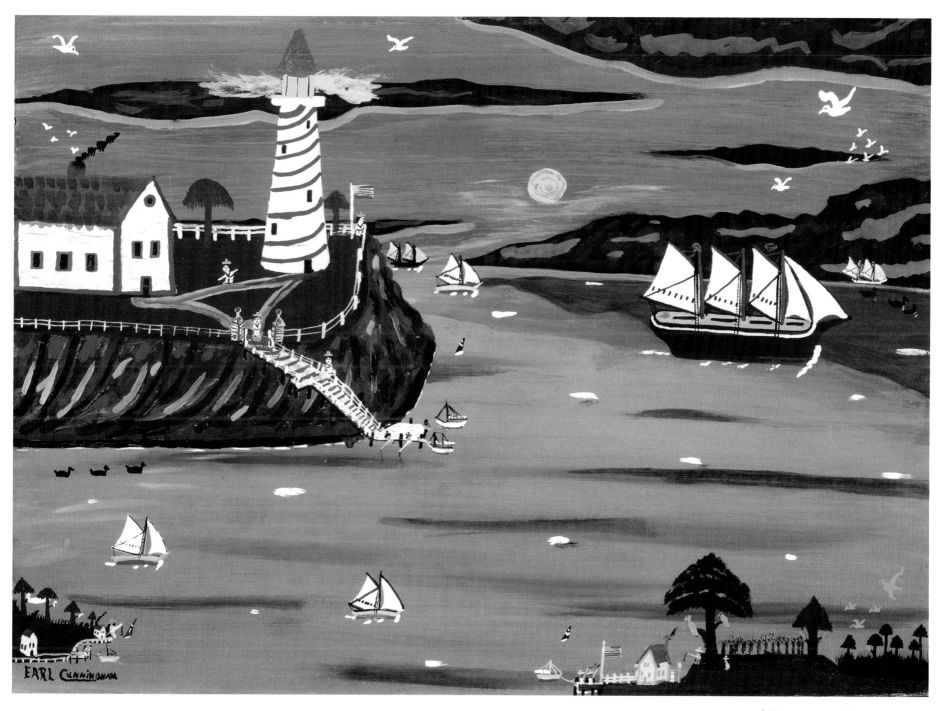

35. Sunrise at Lighthouse, ca. 1960

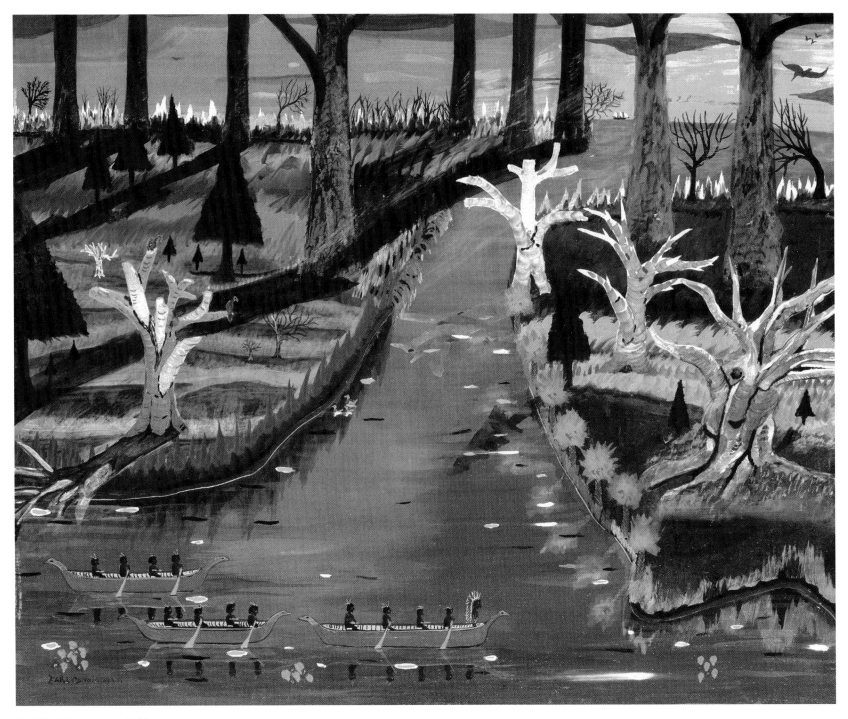

36. Chief Osceola, *ca. 1962*

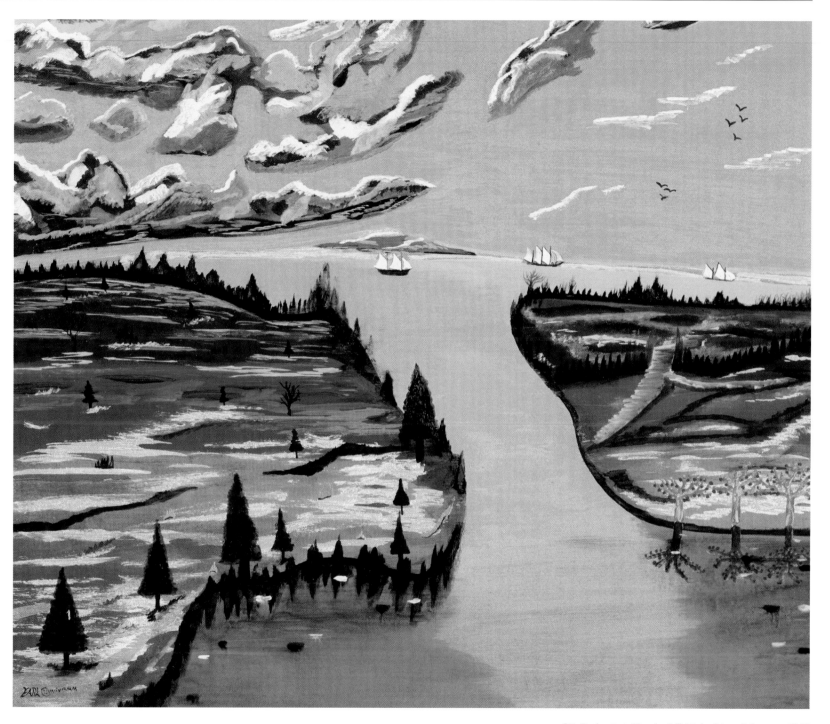

37. Gathering Clouds Off Little River Inlet, ca. 1962

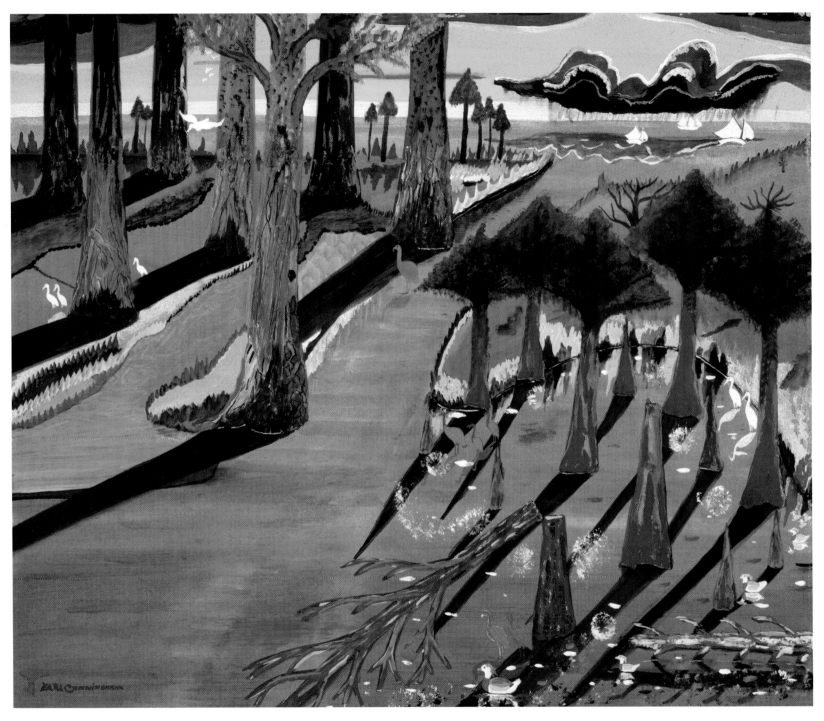

38. Old Thunder Cloud, *ca. 1960*

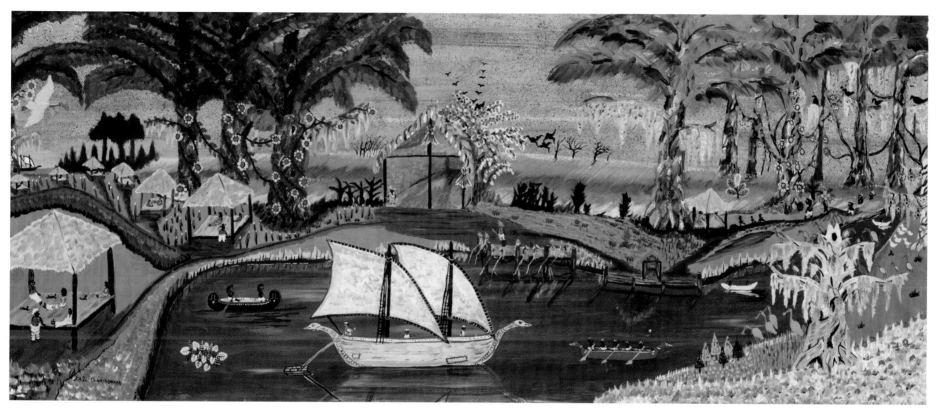

39. Seminole Indian Summer Camp, *ca. 1963*
National Museum of American Art
Smithsonian Institution, Washington, D.C.

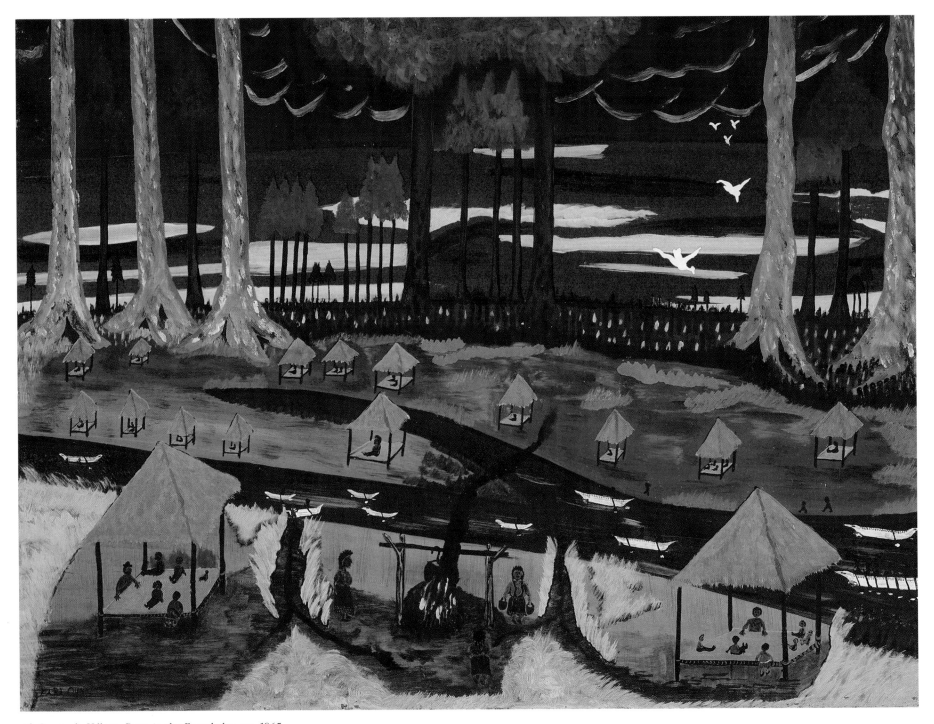

40. Seminole Village, Deep in the Everglades, ca. 1965

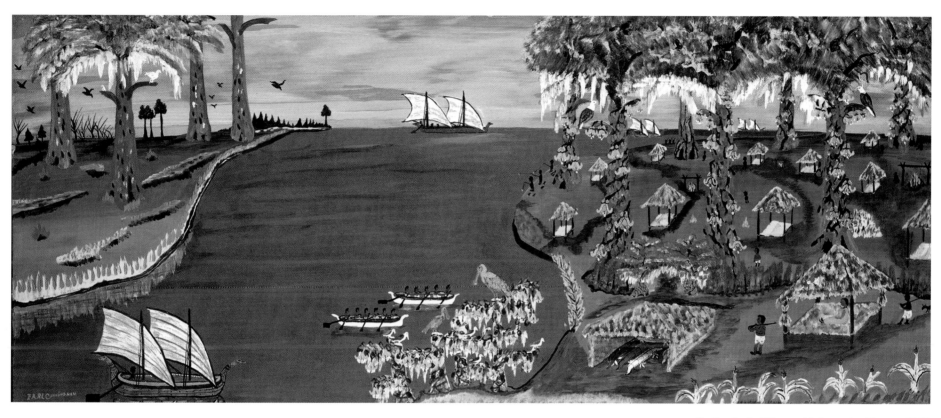

41. Seminole Village with Lavender Sky, *ca. 1965*
Lightner Museum, St. Augustine

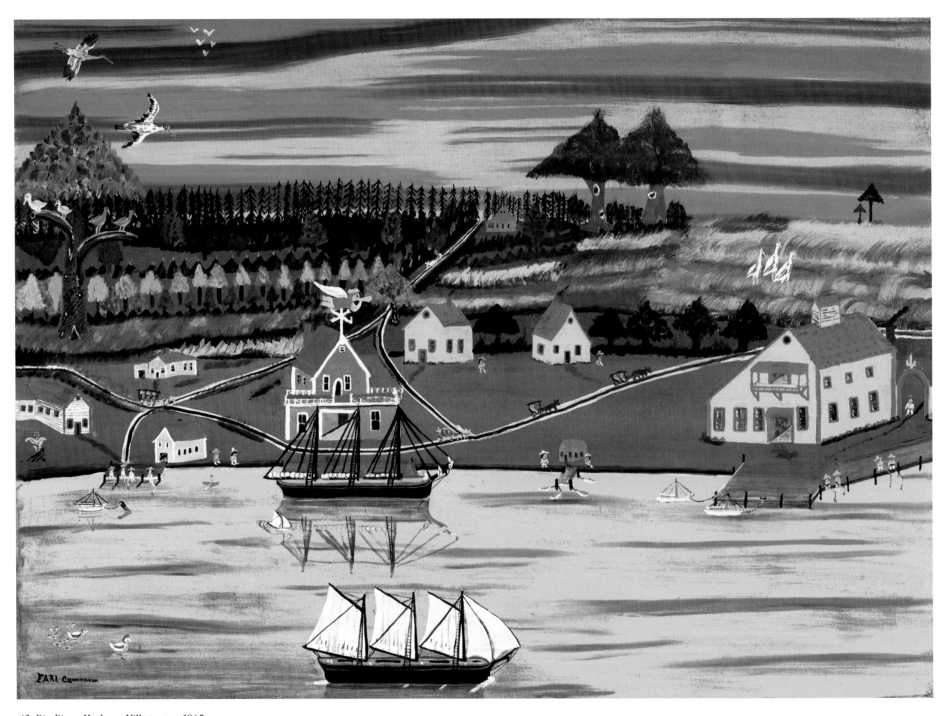

42. Big Pines Harbour Village, ca. 1965

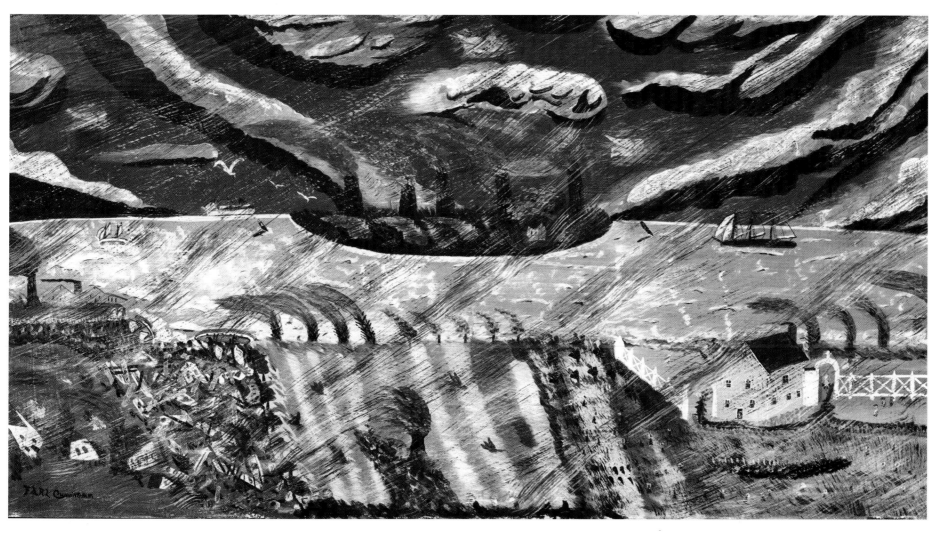

43. *Hurricane, ca. 1970*
 The Museum of Arts and Sciences, Daytona Beach

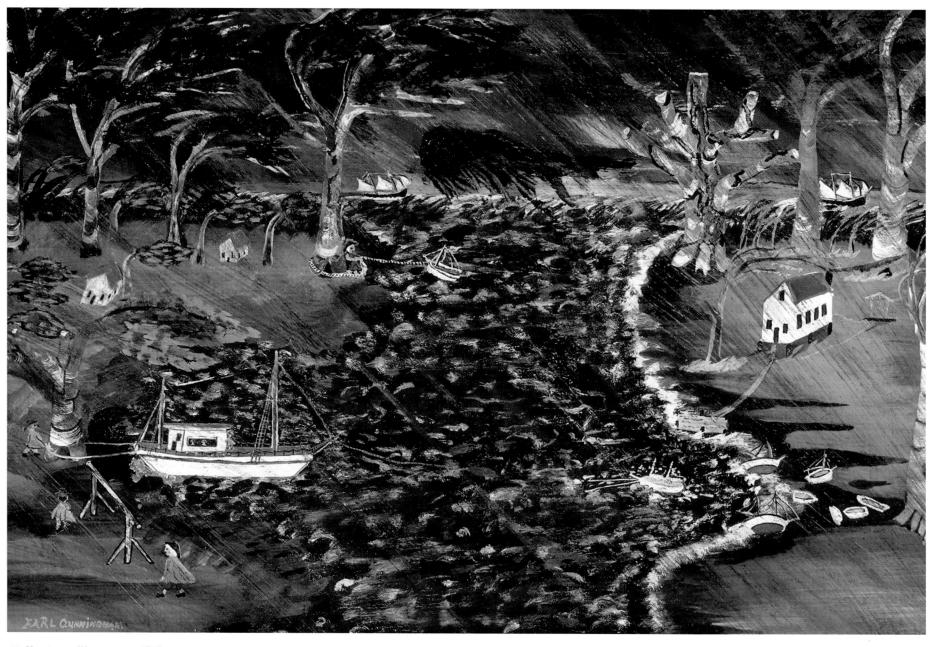

44. Hurricane Warning, *ca. 1970*

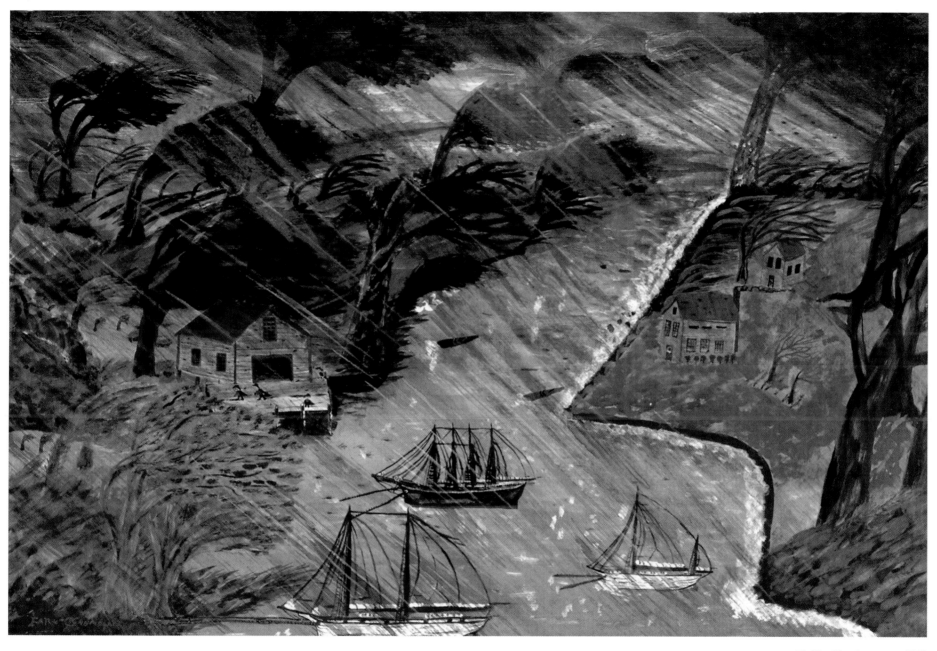

45. The Hurricane, ca. 1970

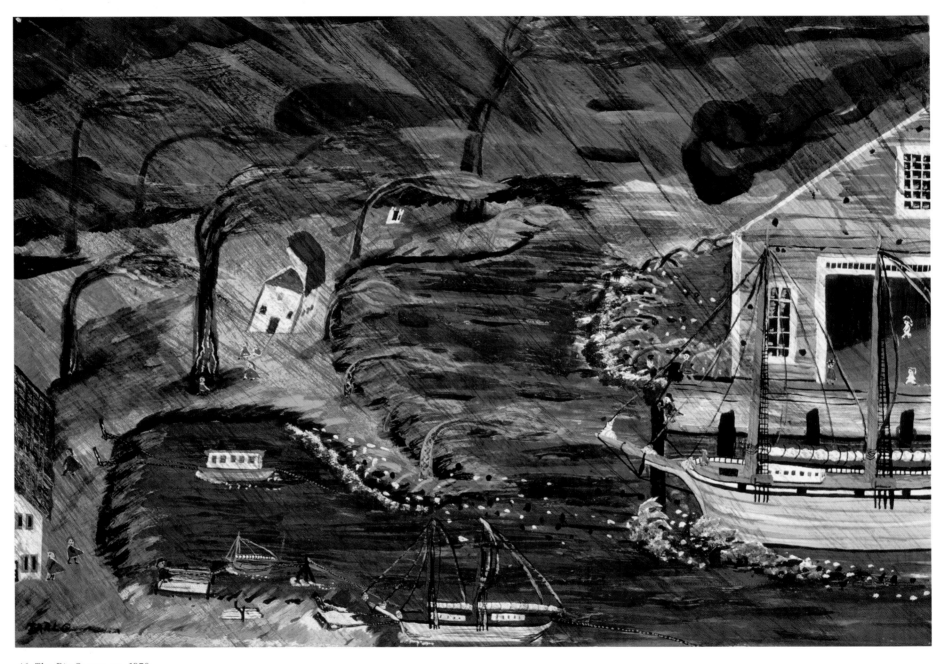

46. The Big Storm, *ca. 1970*

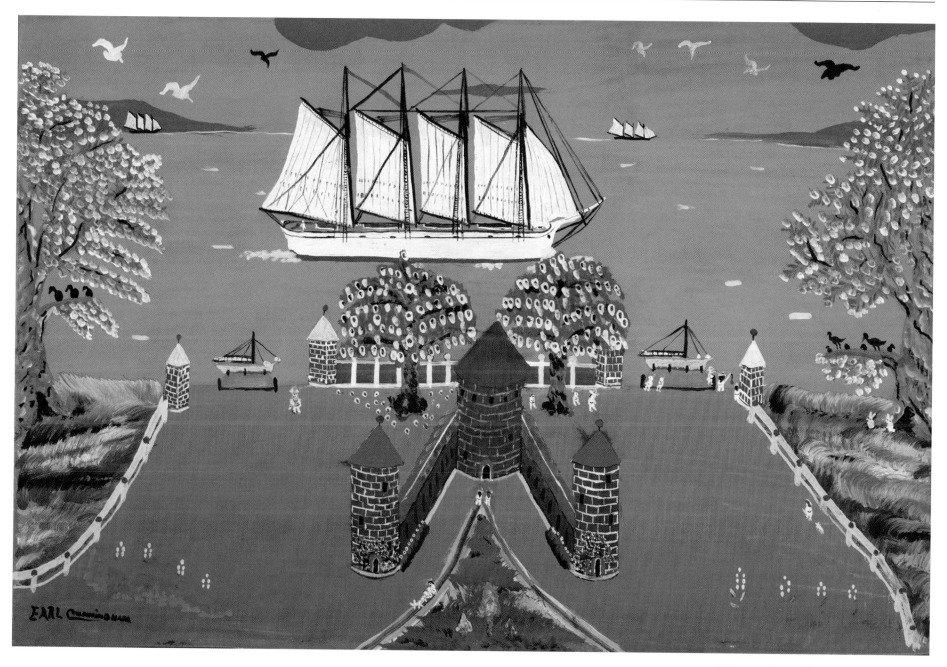

47. Summertime at Fort San Marcos, ca. 1970

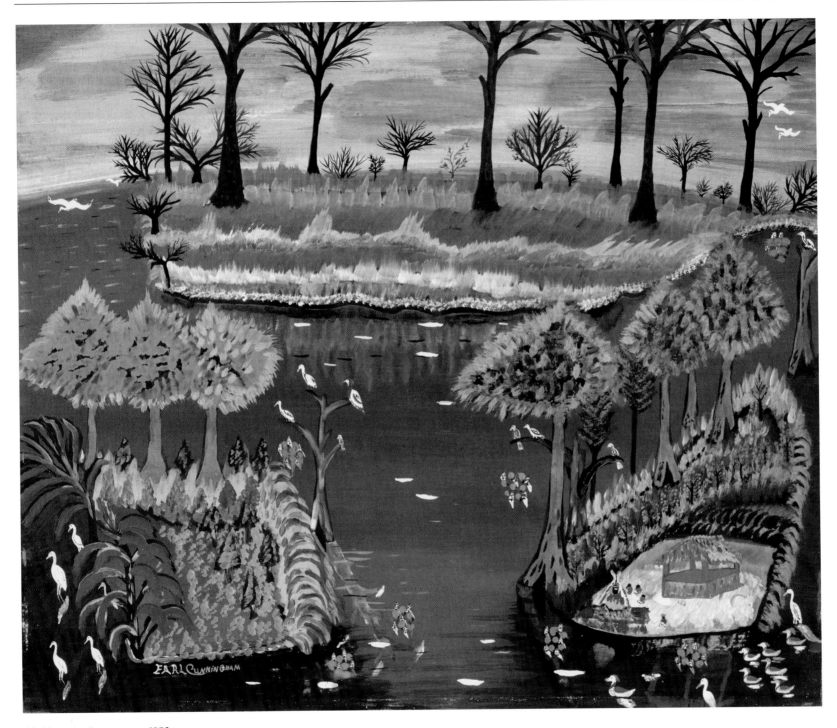

48. Mosquito Lagoon, *ca. 1972*

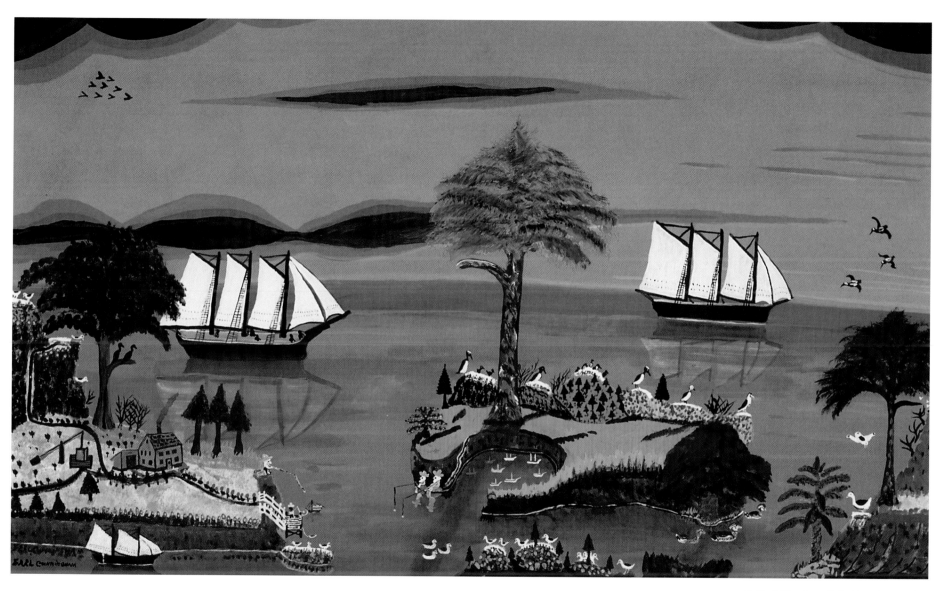

49. Red Sky Over Folly Beach, ca. 1975

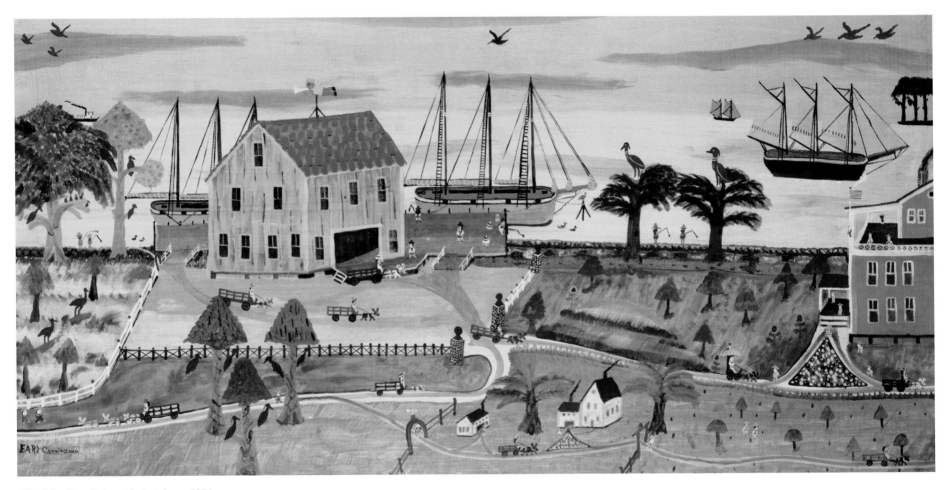

50. Ship Chanderly with Angel, *ca. 1976*
 Museum of American Folk Art, New York

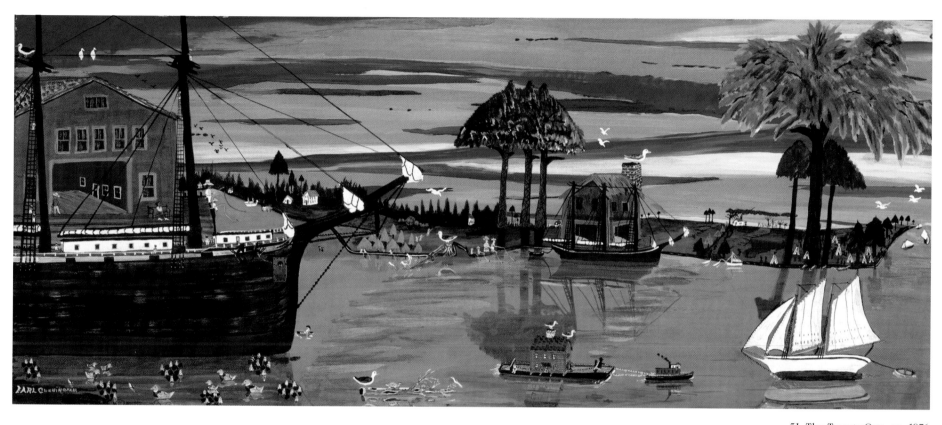

51. The Twenty-One, ca. 1976

Checklist of the Exhibition

1. Stratton Island, 1914
 Oil on board 7.75 x 9.5 in. Signed l.r.: Earl
 Cunningham. Inscribed and dated on reverse Stratton
 Island, Maine 1914. Earl Cunningham at this time 21
 years old. $8.00 price in 1914. M.M.A.F.A. #P-2

2. Delightful Day At Blue Bay, ca. 1925
 Oil on Masonite 11 x 30 in. Signed l.r.: Earl
 Cunningham, M.M.A.F.A. #220

3. Windy Cove, ca. 1925
 Oil on Masonite 16 x 24 in. Signed l.l.: Earl
 Cunningham, Collection of Marilyn and Michael
 Mennello #18

4. Untitled, ca. 1928
 Oil on canvasboard 19.50 x 23.50 in. Signed l.l.: Earl
 Cunningham, Gift of Mrs. Justin Dart to M.M.A.F.A.

5. Houseboat on Flamingo Bay, ca. 1926
 Oil on Masonite 15.75 x 20.25 in. Signed l.r.: Earl
 Cunningham, High Museum of Art, Atlanta

6. Marsh Birds, ca. 1928
 Oil on Masonite 16 x 20 in. Signed l.l.: Earl
 Cunningham, Collection of Marilyn and Michael
 Mennello #D-15

7. Ashepoo River in Spring, ca. 1930
 Oil on Masonite 20 x 24 in. Signed l.r.: Earl
 Cunningham American Primitive, M.M.A.F.A. #42

8. Town on Pleasant Point, ca. 1930
 Oil on Masonite 20 x 24 in. Signed l.l.: Earl
 Cunningham, M.M.A.F.A. #218

9. View of Volcano Island, ca. 1930
 Oil on Masonite 20 x 24 in. Signed l.l.: Earl
 Cunningham, Collection of Marilyn and Michael
 Mennello #228

10. Tranquil Forest, ca. 1933
 Oil on Masonite 22 x 26 in. Signed l.l.: Earl
 Cunningham, M.M.A.F.A. #D-08

11. Sanctuary, ca. 1933
 Oil on Masonite 21.25 x 26 in. Signed l.r.: Earl
 Cunningham, M.M.A.F.A. #D-13

12. Island Farm, ca. 1935
 Oil on Masonite 21.50 x 26 in. Signed l.r.: Earl
 Cunningham, Collection of Marilyn and Michael
 Mennello #D-7

13. Valley Freight Train, ca. 1938
 Oil on Masonite 16 x 25.50 in. Signed l.l.: Earl
 Cunningham, Abby Aldrich Rockefeller Folk Art
 Center, Williamsburg, Virginia

14. Old Mill House, ca. 1938
 Oil on Masonite 18 x 24 in. Signed l.l.: Earl
 Cunningham, M.M.A.F.A. #265

15. Red Viking Portrait, ca. 1938
 Oil on Masonite 15.50 x 36 in. Signed l.l.: Earl
 Cunningham, M.M.A.F.A. #114

16. Icy Harbor, ca. 1940
 Oil on Masonite 15.75 x 23.75 in. Signed l.l.: Earl
 Cunningham, M.M.A.F.A. #216

17. River Camp, ca. 1940
 Oil on Masonite
 16 x 20 in. Signed l.l.: Earl Cunningham,
 M.M.A.F.A. #27

18. Night Scene, ca. 1940
 Oil on Masonite 12 x 22 in. Signed l.l.: Earl
 Cunningham, Collection of Marilyn and Michael
 Mennello #84

19. Squirrel Hollow, 1940
 Oil on Masonite 19 x 30 in. Signed l.l.: Earl
 Cunningham Inscribed and dated 1940 — Picture
 frame made by Earl Cunningham in 1940,
 St. Augustine, Florida, Collection of Marilyn and
 Michael Mennello #56

20. Pawley's Island, 1945
 Oil on Masonite 22 x 29 in. Signed l.l.: Earl
 Cunningham, Collection of Marilyn and Michael
 Mennello #245

21. Seminole Everglades, ca. 1945
 Oil on Masonite 20.75 x 26.75 in. Signed l.l.: Earl
 Cunningham, The Metropolitan Museum of Art,
 New York

22. Nassau Sound, ca. 1945
 Oil on Masonite 19 x 48 in. Signed l.l.: Earl
 Cunningham, Collection of Marilyn and Michael
 Mennello #54

23. Houseboat at Oyster Key, ca. 1945
 Oil on Masonite 20.50 x 24 in. Signed l.r.: Earl
 Cunningham, M.M.A.F.A. #20

24. Reflections, ca. 1945
 Oil on Masonite 17.25 x 29 in. Signed l.l.: Earl
 Cunningham, M.M.A.F.A. #119

25. Palm Beach, 1950
 Oil on Masonite 19 x 48 in. Signed l.l.: Earl
 Cunningham. Inscribed on reverse: This frame made
 of California Redwood by Earl Cunningham in St.
 Augustine, Florida and picture 1950, Collection of
 Marilyn and Michael Mennello #D-1

26. The Everglades, ca. 1950
Oil on Masonite 32.50 x 60.75 in. Signed l.l.: Earl
Cunningham, John F. Kennedy Library and Museum,
Boston, Massachusetts

27. Summer Day at Over-Fork, ca. 1950–55
Oil on Masonite 22.50 x 42 in. Signed l.l.: Earl
Cunningham, Collection of Marilyn and Michael
Mennello #101

28. Warehouse at Hokona Settlement, ca. 1950
Oil on Masonite 20 x 48 in. Signed l.l.: Earl
Cunningham, Collection of Marilyn and Michael
Mennello, R.H. 99

29. Barbeque — Seminole Style, ca. 1955
Oil on Masonite 17 x 40 in. Signed l.l.: Earl
Cunningham American Primitive, Collection of
Marilyn and Michael Mennello, K-91

30. Visiting White Tee Pee, ca. 1955
Oil on Masonite 22.50 x 43 in. Signed l.l.: Earl
Cunningham, Collection of Marilyn and Michael
Mennello #34

31. New England Landscape, ca. 1955
Oil on Masonite 15.50 x 19.50 in. Signed l.r.: Earl
Cunningham American Primitive, Orlando Museum
of Art, Florida

32. View from the Widow's Walk, ca. 1955
Oil on Masonite 20.75 x 26.25 in. Signed l.l.: Earl
Cunningham, M.M.A.F.A. # Mar 1

33. Midnight Cruise, ca. 1955
Oil on Masonite 17 x 48 in. Signed l.l.: Earl
Cunningham, M.M.A.F.A. #289

34. Banyon Tree Camp, ca. 1956
Oil on Masonite 17 x 40.50 in. Signed l.l.: Earl
Cunningham, Collection of Marilyn and Michael
Mennello #215

35. Sunrise at Lighthouse, ca. 1960
Oil on Masonite 17 x 24 in. Signed l.l.: Earl
Cunningham, M.M.A.F.A. #217

36. Chief Osceola, ca. 1962
Oil on Masonite 20 x 24 in. Signed l.l.: Earl
Cunningham, M.M.A.F.A. #29

37. Gathering Clouds Off Little River Inlet, ca. 1962
Oil on Masonite 20 x 24 in. Signed l.l.: Earl
Cunningham, Collection of Marilyn and Michael
Mennello #28

38. Old Thunder Cloud, ca. 1962
Oil on Masonite 20 x 24 in. Signed l.l.: Earl
Cunningham, M.M.A.F.A #255

39. Seminole Indian Summer Camp, ca. 1963
Oil on Masonite 16.75 x 40.75 in. Signed l.l.: Earl
Cunningham, National Museum of American Art,
Smithsonian Institution, Washington, D.C.

40. Seminole Village, Deep in the Everglades, ca. 1965
Oil on Masonite 20.75 x 26.75 in. Signed l.l.: Earl
Cunningham, M.M.A.F.A. #Mar 2

41. Seminole Village with Lavender Sky, ca. 1965
Oil on Masonite 17 x 41 in. Signed l.l.: Earl
Cunningham, Lightner Museum, St. Augustine,
Florida

42. Big Pines Harbour Village, ca. 1965
Oil on Masonite 27 x 37 in. Signed l.l.: Earl
Cunningham, M.M.A.F.A. #D-05

43. Hurricane, ca. 1970
Oil on Masonite 22.75 x 42 in. Signed l.l.: Earl
Cunningham, The Museum of Arts and Sciences,
Daytona Beach, Florida

44. Hurricane Warning, ca. 1970
Oil on Masonite 16 x 24 in. Signed l.l.: Earl
Cunningham, M.M.A.F.A. #D-11

45. The Hurricane, ca. 1970
Oil on Masonite 16 x 24 in. Signed l.l.: Earl
Cunningham, M.M.A.F.A. #D-09

46. The Big Storm, ca. 1970
Oil on Masonite 16 x 24 in. Signed l.l.: Earl
Cunningham, M.M.A.F.A. #D-10

47. Summertime at Fort San Marcos, ca. 1970
Oil on Masonite 16 x 24 in. Signed l.l.: Earl
Cunningham, M.M.A.F.A. #152

48. Mosquito Lagoon, ca. 1972
Oil on Masonite 21 x 25 in. Signed l.l.: Earl
Cunningham, Collection of Marilyn and Michael
Mennello #30

49. Red Sky Over Folly Beach, ca. 1975
Oil on Masonite 31.25 x 44.50 in. Signed l.l.: Earl
Cunningham, Collection of Marilyn and Michael
Mennello #57

50. Ship Chanderly with Angel, ca. 1976
Housepaint or tempera on Masonite 24 x 46 in.
Signed l.l.: Earl Cunningham, Collection of the
Museum of American Folk Art, New York; Gift of
Theresia Paffe 1979.10.1

51. The Twenty-One, ca. 1976
Oil on Masonite 17 x 40.75 in. Signed l.l.: Earl
Cunningham, Collection of Marilyn and Michael
Mennello #290

1893 June 30. Born Erland Ronald Cunningham in Edgecomb, Maine, near Boothbay Harbor, fifty-nine miles from Portland. Parents are Charles and Elwilda Drake Cunningham; there are two older sisters and later, three younger brothers. Their father lives and works on the farm that has been in the family since the early nineteenth century. According to family tradition, they were of Scottish descent and had emigrated to Nova Scotia and then moved south to Maine.

1906 Leaves home at age thirteen. His mother makes him promise that he will finish the eighth grade; his father then pronounces him a man, and he strikes out on his own. Makes his living as a tinker and is befriended by the son of the inventor and founder of the Diamond Match Company. Returns to Boothbay Harbor for part of each year until 1937.

1909 Lives in a fisherman's shack on Stratton Island off Old Orchard Beach, Maine. Supports himself by peddling and by painting salvaged wood with pictures of boats and New England Farms for fifty cents each. Eventually acquires a rowboat, tent, and a twenty-two-foot sailboat, which he sails to within fifteen miles of New York City, to Jamaica Bay, Sandy Hook, and Long Island Sound, and even up beyond the narrows of the Hudson River.

1912 May 1. Receives a certificate from Hamlin Foster School of Automobile Engineering, Portland, Maine. Also finds time to study coastal navigation and receives a government license as a pilot of harbors and rivers.

Prior to World War I

 Sails on giant coastal ships, 159 to 250 feet long, schooner-rigged, with four and five masts. Travels down the East coast to Florida and ports on the way, carrying coal, naval stores, and other cargo. Relates the story that he was once taken by "coaster" to Labrador, Canada, where he was put ashore for two weeks to light a huge bonfire for the ship on its return. During that time he befriended raccoons, birds, and other animals, many of which appear later in his paintings.

ca. 1913 Meets Captain Foster, skipper of the J. P. Morgan family yacht, the *Grace*, and eventually learns to sail the vessel. Saves the *Grace* from possible disaster by repairing a shackle that had been undone by the weather. In return for Earl's diligence, Captain Foster goes to Boston and returns with an eleven-foot mahogany-topped white cedar canoe, a gift from the Morgan family. Later, a loan from Captain Foster enables him to buy a twenty-two-foot sailboat.

1913 June. Postcard from Boothbay Harbor mentions traveling "from Portland, Maine to Boothbay Harbor on the *Grace* ... Captain Foster's daughter and I went to the fire around nine o'clock at night June 1913." Fire destroys a large hotel called the Menawarmet.

1914 August. Stays in cabin at Pendleton homestead, Crescent Beach Road, Anastasia Island, Florida. That same year sells a painting for eight dollars.

1915 June 29. Marries Iva Moses, a piano teacher, whom he calls Maggie throughout their mar-

riage. Buys a thirty-five-foot cabin cruiser named the *Hokona*, on which he and his bride live. Drives a truck for the navy during World War I and is sent to Jacksonville, Florida, to test an instrument used to detect alloys in junk metals. While on this job visits St. Augustine for the first time.

1916 *Hokona* is docked near Cape Elizabeth, Maine. Photograph of chickens bears inscription "product of our farm 1916.

1917 Photograph of the vessel *Bay State* grounded on the rocks, Cape Elizabeth, near Portland, Maine. Later uses this scene in a painting.

1918–ca.1928

 For a decade after World War I spends the winters in Florida at Tampa Bay, Cedar Keys, and St. Augustine, digging for Indian relics and collecting opalized coral to take back to Maine to sell. Also catches fiddler crabs on the beaches of Anastasia Island, Florida, which he preserves and takes back to Maine.

1919 In Freeport, Maine, and Schenectady, New York.

1920 Lives in Freeport, Maine. Has several buildings and a sawmill.

1921 July. Photograph taken in Freeport, Maine, with the truck named *Dirigo: The Good Barge*. July 20. Travels between Florida and Maine. August 6. Visits Niagara Falls. August 8. Travels the coast of Lake Erie beyond Lackawanna, New York. October 14. Spends time in Ohio; the Cunninghams husk eight hundred bushels of corn for a Mr. Riddles.

1922 April. Visits Cartersville, Georgia.
August. Photograph taken near Cartersville shows Etowah burial mounds in the background. On the reverse Cunningham notes, "Found lots of things here: 1922–23–24–25."

1923–24 Continues to visit Anastasia Island and St. Augustine, Florida. Stays long enough to invest in a small motorized tractor.

1925 Rents a house in the district of West Augustine, St. Augustine, Florida, for five years; catches fiddler crabs and sends them to Maine as well as all over the U.S. Continues to call Maine home; moves from Freeport to Boothbay Harbor. October 19. Earl's brother Donald dies in a sawmill accident. Family situation becomes difficult.

ca. 1920s–40
Maintains a twenty-five-acre farm in Maine, which he names "Fort Valley," and plans a museum.

1936 Sells his house in Maine. Some time after this date his marriage ends in divorce.

1938 January. Again visits Cartersville, Georgia.

1940 Sells Fort Valley farm and purchases a fifty-acre farm in Waterboro, South Carolina. Has museum project under way when World War II begins. Farm is converted to raise chickens for the army; nevertheless continues to paint.

1949 Moves to 51–55 St. George Street, St. Augustine, Florida, and establishes Over Fork Gallery. Landlady, close friend, and patron is fifty-one-year-old Theresia (Tese) Paffe, who lives upstairs.

ca. 1950 Paints series of twenty pictures (now lost) of Native Americans for the Michigan Historical Society. Notes on back of a photograph of Mackinac Island, Michigan: "I have none of them now. They sold for $250.00 each. Each was different." Finds Native-American stone figure of bison in Georgia mountains.

1953 February 1. Oil painting entitled *American Primitive* offered for sale in catalogue of St. Augustine Art Association.

1955 Exhibits *Hilton Head*. Notes on back of painting, "Was in the National Show in St. Augustine, Florida, April 1955. Private showing."

1959 February 12. Takes pride in becoming a member of the International Oceanographic Foundation and has certificate framed, even though membership in the foundation is similar to belonging to the National Geographic Society.

1960 Has business card printed identifying himself as "Earl R. Cunningham, Zoologist" with the word "Specimens" below. Card also bears family crest with the name Cunningham; address is listed as 51–53–55 St. George Street.

1961 January 27. Ships painting entitled *The Everglades* to Jacqueline Kennedy in the White House. Declares its value to be $1,200. May 9. Painting sent to Mrs. Kennedy is acknowledged by her personal secretary, Letitia Baldrige, in a letter to Cunningham.

1962 Visits his nephew Carroll Winslow and his wife, Beverly, in Maine.

1968 Identifies himself on a business card as a "Primitive Artist."

1969 November. Meets Marilyn Logsdon Wilson (now Mennello) and her friend Jane Dart; is persuaded to sell paintings to both of them.

1970 May 31–July 5. Loch Haven Art Center, Orlando, Florida (now the Orlando Museum of Art), holds Cunningham's first museum exhibition, "The Paintings of Earl Cunningham." Jerry Uelsmann takes a series of photographs of the artist and his studio.

1972 September 19. Is requested to move by the first of the year by Theresia Paffe.

1973 Both he and Theresia Paffe move to a shop-home-studio on Florida State Road A1A (U.S. 1), which is also 1004 N. Ponce De Leon Boulevard, St. Augustine.

1974 August 8–September 5. Museum of Arts and Sciences, Daytona Beach, Florida, holds exhibition "Earl Cunningham: American Primitive," featuring over two hundred paintings. According to museum director John Surovek, the artist wishes the paintings to be hung from floor to ceiling.

1975 Notes in diary: "Counted my paintings today August 15. I have 330 all in frames."

1976 June 3. Notes in diary: "Finished all paintings today making me 405 on hand now."

1977 December 29. During a visit from his nephew Carroll Winslow and his wife, Earl Cunningham shoots himself. His funeral takes place January 3, 1978.

BOOKS

Bishop, Robert. *Folk Painters of America*. New York: E.P. Dutton, 1979.

Johnson, Jay, and William C. Ketchum, Jr. *American Folk Art of the Twentieth Century*. New York: Rizzoli, 1983.

Meyer, George H., ed., with George H. Meyer, Jr., and Katherine P. White, assoc. eds. *Folk Artists Biographical Index*. Detroit: Gale Research Company, 1987.

Rosenak, Chuck, and Jan Rosenak. *Museum of American Folk Art Encyclopedia of Twentieth-Century American Folk Art and Artists*. New York: Abbeville Press, 1990.

Sellen, Betty-Carol. *20th Century American Folk, Self-Taught, and Outsider Art*. Neal-Schuman Publishers, Inc. 1993.

MUSEUM PUBLICATIONS

Brigham, Charles F. "Biographical Survey." In *Earl Cunningham, American Primitive*. Exhibition catalogue, Museum of Arts and Sciences, Daytona Beach, Florida, August 8–September 5, 1974.

Duncan, Katherine. "Earl Cunningham; His Carefree American World." *Polk Museum of Art Newsletter*, Lakeland, Florida (January–April, 1990): 5

"Earl Cunningham Exhibit to Open at McKissick Museum," January 11, 1998. *News, Office of Media Relations*. University of South Carolina (Columbia, South Carolina)

"Earl Cunningham, Folk Artist: The Marilyn L. and Michael A. Mennello Collection." *Huntsville Museum of Art Calendar* (September–November, 1989): 3.

"Earl Cunningham, His Carefree American World: the Mennello Collection." *Orlando Museum of Art Magazine* 8, no. 3 (September–November, 1986): 5.

"Earl Cunningham: Painting an American Eden." Orlando Museum of Art Newsletter, *Exhibitions*, November/December 1995, 3.

"Earl Cunningham: Painting an American Eden." *The Farnsworth Art Museum Newsletter* (Rockland, Maine) September–November, 1996

"Earl Cunningham: Painting an American Eden." *Under the Dome*, McKissick Museum, University of South Carolina, January 1997

"Earl Cunningham: Painting an American Eden." Westmoreland Museum of American Art, *Viewer* (Greenberg, Pennsylvania) Winter, 1996/1997

Goley, Mary Anne. "Folk Art Traditions: Three Contemporary Masters." In *Earl Cunningham, His Carefree American World*. Washington, D.C.:Federal Reserve Board Building, January 23, 1990.

Henry, John B., III. *Two Centers of American Folk Art: Nineteenth and Twentieth Century Masterworks from the Collection of Mr. and Mrs. Robert P. Marcus*. Vero Beach, Florida: Center for the Arts, August 1987.

Libby, Gary R. "Earl Cunningham: American Folk Artist." *Museum of Arts and Sciences Magazine*, Daytona Beach, Florida (Spring 1988): 9.

Mennello, Marilyn. *Earl Cunningham, Folk Artist, 1893–1977: His Carefree American World*. Introduction by Henry Moran and Edeen Martin. Exhibition catalogue, Exhibits USA: A National Division of Mid-American Arts Alliance, Kansas City, Missouri, January 1988–July 1990.

—— *Earl Cunningham, Folk Artist, 1893–1977: His Carefree American World*. Exhibition catalogues, with different introductions for each venue: Introduction by Gary R. Libby, Museum of Arts and Sciences, Daytona Beach, Florida, April 1988. Introduction by Bill Atkins, Triton Museum of Art, Santa Clara, California, December 10, 1988–February 5, 1989. Introduction by Jo Farb Hernandez, Monterey Peninsula Museum of Art, Monterey, California, February 18–May 14, 1989. Introduction by Martha Longenecker, Mingei International Museum of World Folk Art, La Jolla, California, August 5–September 1989. Introduction by David M. Robb, Jr., Huntsville Museum of Art, Huntsville, Alabama, October 8–November 12, 1989. Introduction by Ken Rollins,

Polk Museum of Art, Lakeland, Florida, December 8, 1989–February 25, 1990. Introduction by Charles Thomas Butler, Huntington Museum of Art, Huntington, West Virginia, May 20–July 15, 1990. Introduction by R. Andrew Maas, Tampa Museum of Art, Tampa, Florida, February 2–March 29, 1992.

Surovek, John H. "Introduction." In *Earl Cunningham, American Primitive*. Exhibition catalogue, Museum of Arts and Sciences, Daytona Beach, Florida, August 8–September 5, 1974.

Valdes, Karen. "A Separate Reality, Florida Eccentrics." Exhibition catalogue, Museum of Art, Fort Lauderdale, April 23–October 1987.

MAGAZINE AND NEWSPAPER ARTICLES

"American Eden Travels to Farnsworth," *The Courier-Gazette* (Rockland, Maine), November 7, 1996.

"American Painting Sales in New York." *Antiques & The Arts Weekly*, January 31, 1997, 71.

"American Primitive." *Eastern Review* (April 1988): 15.

Barrett, Didi. "Miniatures: Earl Cunningham Exhibitions." *The Clarion* 13, no. 1 (Winter 1988): 14.

Bishop, Philip. "Cunningham Show: A Curious, Colorful Vision." *The Orlando Sentinel*, October 22, 1995, F1, F5.

"Breckenridge Fine Arts Center Presents Earl Cunningham Exhibit." *Breckenridge American News* (Texas), May 26, 1990, 4B.

Brigham, Charles. "Mr. Earl Cunningham, More Than a Man." *The Vacationer* (Daytona Beach, Florida), September 26, 1973, 6.

Busby, Mary Ann. "Arts Center Shows Folk Artist's Work." *Springdale News* (Arkansas), April 1989.

Craven, Waldo. "Earl Cunningham Works Open at Art Museum." *Jacksonville Register*, September 24, 1987, 17.

"Creating an Eden," *The State, Weekend* (Columbia, South Carolina), January 16, 1998.

"Cunningham Collection on View." *The St. Augustine Record*, October 24, 1978, 3.

"Cunningham Exhibit Opening." *The St. Augustine Recort*, December 12, 1979, B2.

"Cunningham Exhibit," *The Florida Times-Union* (Jacksonville, Florida) May 1, 1994.

"Cunningham Folk Paintings at Museum of Arts and Sciences." *Volusia Arts.* April 8–14, 1988, 9.

"Cunningham, Moses, St. Etienne Gallery." *Where,* (New York) March, 1995, 18.

"Cunningham Paintings on Exhibit at the Norton." *Palm Beach Today*, August 13, 1994, Vol. V, no. 47.

"Cunningham Works on Display." *The Traveler* (St. Augustine, Florida), November 8, 1978, 11.

Darrel, Joseph. "Earl Cunningham's Carefree American World." *Vue: The Arts Magazine* (Jacksonville, Florida) 3, no. 2 (September 1987): 21.

Day, Jeffrey. "1998 Visual Arts Season Takes Off With Array of Major Exhibits," "Earl Cunningham Creating an Eden," *Tempo* (Columbia, North Carolina) January 7, 1998.

Day, Jeffrey. "Artist Finds His Eden in a Colorful Coastal World." *Tempo* (Columbia South Carolina), January 25, 1998.

Dishman, Laura Stewart. "Cunningham's Folk Art Reflects Cheerful World." *The Orlando Sentinel*, October 17, 1986, E3.

———. Folk Artist Puts Flights of Fancy in Common Terms." *The Orlando Sentinel*, March 10, 1986, C1, C2.

"Earl Cunningham (1893–1977)." *The New Yorker*, February 10, 1997, 1G.

"Earl Cunningham (1893–1977), Grandma Moses (1860–1961)." *The New Yorker*, March 13, 1995, 21.

"Earl Cunningham and Grandma Moses Visions of America." *Art in America*, February, 1995.

"Earl Cunningham Art on View at the High to June." *Antiques & The Arts Weekly*, May 27, 1994, 93.

"Earl Cunningham at Norton Gallery of Art" *Art Now Gallery Guide*, Southeast July/August 1994.

"Earl Cunningham, Grandma Moses." *Visions of America Galerie St. Etienne* (New York), January 17, 1995.

"Earl Cunningham: His Carefree American World." *Jacksonville Register 2*, copy 23 (September 10, 1987): 4.

"Earl Cunningham is the Grandma Moses of Florida," Boca Raton, July/August, 1994.

"Earl Cunningham," *New York Arts*, January 17, 1997.

"Earl Cunningham 'One Man Exhibition.'" *The Vacationer* (St. Augustine, Florida), August 28, 1974, 4–9.

"Earl Cunningham: Painting an American Eden,"*Abrams Art Books*, Spring/Summer 1994.

"Earl Cunningham: Painting an American Eden," *ARTbibliographies Modern*, Vol. 26, no. 2, Old Clarendon Ironworks, Oxford, England 1995.

"Earl Cunningham: Painting an American Eden Exhibit at the High Museum's Folk Art & Photography Galleries," *Atlanta Homes & Lifestyles*, February, 1994.

"Earl Cunningham's American Fantasies." *Antique & The Arts Weekly*, January 24, 1997, 8.

"Earl Cunningham's American Fantasies," *Folk Art Messenger* (Richmond, Virginia) Fall 1997, 15.

"Earl Cunningham's American Fantasies," *Maine Antiques Digest*, January 1997, 11-A.

"Earl Cunningham's American Fantasies," *The New York Times, The Living Arts,* January 17, 1997, B29.

"Earl Cunningham's New England Autumn at the High Museum's Folk Art & Photography Galleries," *Atlanta,* February, 1994.

"Earl Cunningham's Norsemen Discovering The New World is at the High Museum of Art Folk Art Gallery." *The Atlanta Journal/The Atlanta Constitution Leisure*, February 12, 1994.

"Earl Cunningham's Paintings on Display at Museum of Art." *Huntsville News* (Alabama), October 12, 1989, B1.

"Earl Cunningham," *The New York Times, Arts & Leisure Guide*, January 19, 1997, H47.

Edwards, Diana. "A Peaceful, Idyllic World on Canvas." *The Compass* (St. Augustine, Florida), September 10, 1987, 3–4.

"Exhibition Features Work of Edgecomb Native," *Coastal Journal* (Portland, Maine) November 7, 1996.

"Farnsworth Museum to Open Cunningham Show," *Camden Herald* (Camden, Maine) November 7, 1996.

"Farnsworth Opens Cunningham Exhibition," *The Free Press* (Rockland, Maine) November 7, 1996.

Freudenheim, Susan. "Cunningham's Folksy Nautical Works Hard to Resist." *The Tribune* (San Diego, California), August 11, 1989, C6.

Fumea, Laurie, "Exhibits Make Ordinary Special" *Tribune-Review* (Greenburg, Pennsylvania) February 17, 1997.

"Grandma Moses and Earl Cunningham at Galerie St. Etienne." *The New Yorker*, March 13, 1995, 20.

"Grandma Moses and Earl Cunningham in NYC." *Northeast*, February, 1995.

Greenleaf, Ken "Earl Cunningham: Self-Taught, But No Ordinary Folk Artist," *Maine Telegram*, December 8, 1996, E-1, E-3.

Harvey, Karen. "Former Resident's Art Work Gains Value Over Years." *The St. Augustine Record*, July 7, 1994, Vol. XII, no. 47.

Hobbs, Robert, "Earl Cunningham: Painting an American Eden" *American Art Review*, April–May 1994. 152–157.

Hobbs, Robert. "Earl Cunningham: Painting an American Eden." *Folk Art Messenger* (Richmond Virginia), Winter 1994, Vol. 7, no. 2.

Hoffman, Alice J. "The History of the Museum of American Folk Art: An Illustrated Timeline." *The Clarion,* 14, no. 1 (Winter 1989): 59.

Hunting, Mary Anne. "Earl Cunningham: Painting an American Eden," *Antiques,* March 1994.

Hurlburt, Roger. "Earl Cunningham Never Went to School, But His Heavenly Seascapes Now Hang with Monets and Picassos," *Sun-Sentinel* (Ft. Lauderdale, Florida), July 24, 1994.

Hyman, Ann. "Two Jacksonville Art Museum Exhibits Produce Varied Reactions." *The Florida Times-Union/Jacksonville Journal,* September 27, 1987, E1, E5.

Joel, Sharon. "The Collectors and Their Collections." *Antiques and Art Around Florida* (Spring/Winter 1990), 42, 54, 55, 98.

Kohen, Helen L. "Artist Recreated Paradise But Wouldn't Sell It," *The Herald* (Miami), July 23, 1994.

Lagorio, Irene. "St. Augustine's 'Crusty Dragon' and How His Work Came to Monterey." *The Sunday Herald* (Monterey, California), April 2, 1989, D6.

Leighton, Anne. "Cunningham's Genius: Unique Vision in a Genre of Forced Innocence." *Folio Weekly* (Jacksonville, Florida), September 29, 1987, 15.

Lewis, Carol L. "Museums Begin Fall Showings." *The Florida Times-Union/Jacksonville Journal,* September 13, 1987, E1, E9.

Milani, Joanne. "Exhibit Resounds with Rhythms of the Simple Life." *The Tempa Tribune,* February 27, 1992, 1–2.

Murphy, Drew. "On Display: Folk Artist's Carefree American World." *The News-Journal* (Daytona Beach, Florida), April 16, 1988, D1, D10.

Ollman, Leah. "A Free-Spirited but Repetitous Exhibition," *Los Angeles Times,* August 18, 1989, IV, 18.

Parks, Cynthia. "The Crusty Dragon of St. George Street." *Times Journal Magazine* (Jacksonville, Florida), August 20, 1972, 6–11.

Peterson, Kristin D. "Self-Taught Artist Earl Cunningham (1893–1977)." *Art & Auction,* New York, February, 1997, 42.

———. "The Crusty Dragon: His Work Is Private No Longer." *The Florida Times-Union/Jacksonville Journal,* December 16, 1979, J1.

———. "Earl Cunningham: Artist Was Particular About Sharing His Work." *The Florida Times-Union/Jacksonville Journal,* October 26, 1986, D1, D8.

Pincus, Robert L. "Artist's World Is Free of Grim Social Realities." *The San Diego Union,* August 20, 1989, E1, E8.

Rybinski, Paul. "Three New Shows: Exhibits of Colorful Painting Open at Polk Museum of Art." *The Ledger* (Lakeland, Florida), December 7, 1989, C1, C5.

Shearing, Graham, "Exhibits Show Simple Pleasures of Art," *Tribune-Review* (Greenburg, Pennsylvania) March 9, 1997.

Schwan, Gary. "An Exhibit at the Norton Showcases the Late Florida Painter's Colorful and Childlike Vision," *The Palm Beach Post,* July 24, 1994.

Sjostrom, Jan. "Crusty Dragon Exhibit at the Norton," *Palm Beach Daily News,* July 17, 1994.

Smyth, Julie Carr "Orlando to Get Folk Art Collection," *The Orlando Sentinel,* October 22, 1998, A-1, A-9.

Sutherland, Amy. "Earl Cunningham, Primitive Genius," *Maine Telegram,* November 10, 1996.

"The Bold Man & The Sea," *Boca Raton, Florida at its Best,* July/August 1994.

"The Direct Eye: Self-Taught Artists & Their Influence in Twentieth-Century Art." *The BiWeekly, The Metropolitan Museum of Art,* September 4, 1998, 2.

"The High Museum of Art in Atlanta Presents Earl Cunningham: Painting an American Eden," *Sky Magazine, Delta Airlines Communique,* February, 1994.

"The Work of Earl Cunningham at Beacon Hill Fine Art Until March 1." *Antiques & The Arts Weekly,* January 17, 1997, 81.

Thomas, Mary "Local Connections Enliven Excellent Retrospective," *Pittsburg Post-Gazette,* February 22, 1997.

"Two Art Exhibits Open." *The News Journal* (Daytona Beach, Florida), April 9, 1988, 12D.

"Winter Park Couple Funds Art Research." *Winter Park Outlook* (Florida), February 2, 1989, 2.

"Work of Florida Artist Attracts Met." *The Orlando Sentinel,* March 2, 1997, F-4.

"Works of Earl Cunningham to Be Shown in New York." *Antiques and the Arts Weekly,* February 28, 1986, 28.

Yost, Lee. "Mennellos Capture Art Treasure." *La Femme* (Winter Park, Florida) 14, no. 1 (October 23, 1986): 3, 11.

Exhibition History

140 paintings have been shown in a variety of exhibitions at the following locations:

Year	Title, Institution	Dates
1970	"The Paintings of Earl Cunningham" Loch Haven Art Center, Orlando, Florida	May 31–July 5, 1970
1974	"Earl Cunningham: American Primitive," Museum of Arts & Sciences, Daytona Beach, Florida (200 paintings)	August 8–September, 5, 1974
1978	"Earl Cunningham Retrospective," St. Augustine Art Association Gallery	October 29–November 15, 1978
1979	"Teresa Paffe Collection of Earl Cunningham Paintings," The Overfork Gallery, 1004 Ponce de Leon Blvd, Saint Augustine, FL	December, 1979
1979–80	Earl Cunningham Painting and Sculpture, The Museum of Florida History, Tallahassee	December 79–February, 1980
1980	One painting on Loan from the Permanent Collection of the Museum of American Folk Art, NYC to Tampa Museum of Art	January, 1980
1986	"Earl Cunningham (1893–1977): His Carefree American World" presented by The Museum of American Folk Art and The Center for American Art, New York University, at 80 Washington Square East Galleries, New York University (66 paintings)	March 11–April 4, 1986
1986	"Earl Cunningham (1893–1977): His Carefree American World," Orlando Museum of Art, Orlando, Florida (66 paintings)	October 12–October 26, 1986
1987	"A Separate Reality: Florida Eccentrics." Museum of Art, Ft. Lauderdale, Florida (23 paintings)	April 23–July 5, 1987
1987	"A Separate Reality: Florida Eccentrics." Valencia Community College, Orlando, Florida	August 17–September 25, 1987
1987	"Earl Cunningham (1893–1977): His Carefree American World," Jacksonville Art Museum, Jacksonville, Florida	September 17–October 31, 1987
1987	"A Separate Reality: Florida Eccentrics." Fine Arts Gallery and Museum, Florida State University, Tallahassee, Florida	October 2–October 25, 1987
1987–88	Office of the Commissioner of Education, Betty Castor, The Capitol, Tallahassee, Florida (19 paintings)	April 1987–November 1988
1988	"Earl Cunningham (1893–1977): His Carefree American World" Museum of Arts & Sciences, Daytona Beach, FL (65 paintings)	March 24–May 31, 1988
1988–89	"Earl Cunningham (1893–1977): His Carefree American World" Traveling Exhibit sponsored by Mid-America Arts Alliance: Exhibits USA, Mystic Seaport Museum, Mystic, Connecticut (45 paintings)	November 19–March 15, 1989
1988–89	"Earl Cunningham (1893–1977): His Carefree American World" Triton Museum of Art, Santa Clara, California (60 paintings)	December 10–February 4, 1989
1989	"Earl Cunningham (1893–1977): His Carefree American World" Monterey Peninsula Museum of Art, Monterey, California (60 paintings)	February 17–May 14, 1989
1989	"Earl Cunningham (1893–1977): His Carefree American World" The Arkansas Arts Center, Little Rock, AR (40 paintings)	April 20–June 4, 1989

1989 "Earl Cunningham (1893–1977): His July 20–August 21, 1989
Carefree American World" Calvert Marine
Museum, Solomans, Maryland (40 paintings)

1989 "Earl Cunningham (1893–1977): His August 1–September 15, 1989
Carefree American World" Mingei
International Museum of World Folk Art,
La Jolla, California (60 paintings)

1989 "Earl Cunningham (1893–1977): His September 1–September 22, 1989
Carefree American World" Museum of the
Southwest, Midland, Texas (40 paintings)

1989 "Earl Cunningham (1893–1977): His October 8–November 12, 1989
Carefree American World" Huntsville
Museum of Art, Huntsville, AL (60 paintings)

1989 "Earl Cunningham (1893–1977): His November 3–December 1, 1989
Carefree American World" Gray Art
Gallery, East Carolina University,
Greenville, North Carolina (40 paintings)

1989–90 "Earl Cunningham (1893–1977): His December 9–February 18, 1990
Carefree American World" Polk Museum
of Art, Lakeland, Florida (60 paintings)

1989–90 "Earl Cunningham (1893–1977): His December 17–January 28, 1990
Carefree American World" Albany Museum
of Art, Albany, Georgia (40 paintings)

1990 "Folk Art Traditions: Three Contemporary January 23–March 26, 1990
Masters" Federal Reserve Board Gallery,
Washington, DC (10 paintings)

1990 "Earl Cunningham (1893–1977): His May 20–July 15, 1990
Carefree American World" Huntington
Museum of Art, Huntington, West Virginia
(60 paintings)

1990 "Earl Cunningham (1893–1977): His Carefree June 9–July 10, 1990
American World" Breckenridge Fine Arts
Center, Breckenridge, Texas (40 paintings)

1990 "Earl Cunningham" (2 paintings), August, 1990–August, 1992
U.S. Embassy, Luxembourg

1991 "Earl Cunningham" (4 paintings)
U.S. Embassy, Caracus, Venezuela
Ambassador and Mrs. Skol

1992 "Earl Cunningham" (4 paintings)
U.S. Mission in Geneva, Embassy Residence —
Ambassador and Mrs. Morris Abrams

1992 "Earl Cunningham (1893–1977): His February 2–April 6, 1992
Carefree American World" Tampa Museum
of Art, Tampa, Florida (60 paintings)

1994 "Earl Cunningham: Painting An American February 11–June 18, 1994
Eden" High Museum of Art Folk Art and
Photography Galleries, Atlanta, Georgia
(46 paintings)

1994 "Earl Cunningham: Painting An American July 22–September 11, 1994
Eden" Norton Gallery of Art, West
Palm Beach, Florida (46 paintings)

1995 "Earl Cunningham: Painting An American September 30–November 5, 1995
Eden" Orlando Museum of Art,
Orlando, Florida (46 paintings)

1996–97 "Earl Cunningham: Painting An Nov. 10, 1996–Feb. 2, 1997
American Eden" The Farnsworth Art
Museum, Rockland, Maine (46 Paintings)

1997 "Earl Cunningham: Painting An American February 9–April 20, 1997
Eden" Westmoreland Museum of Art,
Greenburg, Pennsylvania (46 paintings)

1998 "Earl Cunningham: Painting An American January 11, 1998–March 2, 1998
Eden" McKissick Museum, University of
South Carolina, Columbia, South Carolina
(46 paintings)

Paintings Represented in Museums

Abby Aldrich Rockefeller Folk Art Center
Williamsburg, Virginia

Akron Art Museum
Akron, Ohio

High Museum of Art
Atlanta, Georgia

John F. Kennedy Library and Museum
Boston, Massachusetts

Lightner Museum
St. Augustine, Florida

Museum of American Folk Art
New York City

National Museum of American Art
Smithsonian Institution, Washington, D.C.

New Orleans Museum of Art
New Orleans, Louisiana

Orlando Museum of Art
Orlando, Florida

The Metropolitan Museum of Art
New York City, New York

The Museum of Arts and Sciences
Daytona Beach, Florida

Honorary Board Members